Keys to Painting
Fur & Feathers

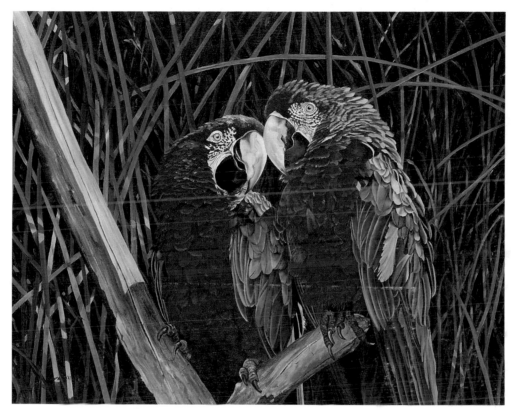

LAURA GILLILAND
"Rollo and Ruby" (Red and Green Macaw)
Oil, 24"×30" (61cm×76cm)

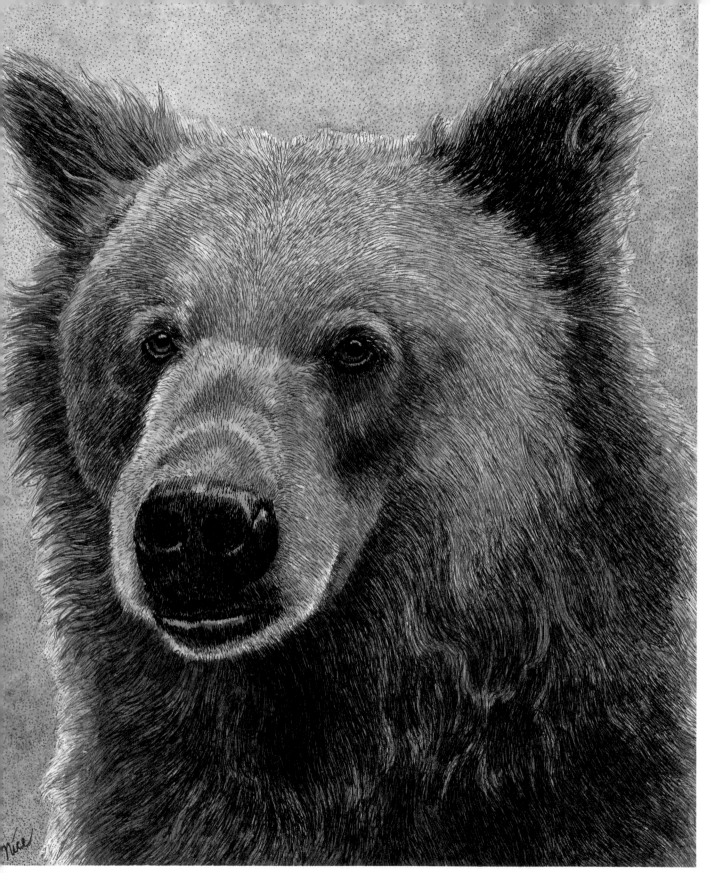

CLAUDIA NICE
"Brown Bear"
Pen and ink; pen and ArtistColor, overlaid with
watercolor, 8½"×7" (21.5cm×18cm)

Keys to Painting
Fur & Feathers

EDITED BY RACHEL RUBIN WOLF

NORTH LIGHT BOOKS

CINCINNATI, OHIO

The following artwork originally appeared in previously published North Light Books (the initial page numbers given refer to pages in the original work; page numbers in parentheses refer to pages in this book).

Greene, Gary. *Creating Textures in Colored Pencil*; pages 94-97, 100; (pages 52-55, 78)

Lawrence, Rod. *Painting Wildlife Textures Step by Step*; pages 20, 24-25, 28-31, 32-37, 42-45, 50-51, 106-107, 110-111, 134, 135; (pages 96, 40-41, 42-45, 98-103, 62-65, 68-69, 90-91, 92-93, 37, 36)

Nice, Claudia. *Creating Textures in Pen & Ink with Watercolor*; pages 10-11, 126, 128-131, 134-135; (pages 74-75, opposite title page, 48-51, 76-77)

Rocco, Michael P. *Painting Realistic Watercolor Textures*; pages 16-19; (pages 70-73)

Rulon, Bart. *Painting Birds Step by Step*; pages 6, 8-11, 22-26, 40-44, 52-57, 87, 90-91, 94-95, 113, 114-115; (pages 11, 24-27, 106-110, 111-115, 120-125, 82, 84-85, 86-87, 83, 88-89)

Seslar, Patrick. *Wildlife Painting Step by Step*; pages 3, 52-53, 54-59, 65, 66-67, 68, 84-87; (pages 80, 38-39, 30-35, 59, 60-61, 58, 116-119)

Tilton, Bill. *First Steps: Drawing and Painting Animals*; pages 28-31, 53-54, 80-81, 86-89; (pages 12-15, 16-17, 18-19, 20-23)

Wolf, Rachel Rubin, ed. *The Best of Wildlife Art*; pages 29, 32, 34, 35, 37, 46, 83, 84, 89, 91, 93, 98, 99, 107, 110; (pages 56, 94, 95, opposite introduction, opposite table of contents, 47, 10, 66, 105, 46, 79, 104, 67, acknowledgment page, 28)

Keys to Painting: Fur & Feathers. Copyright © 1999 by North Light Books. Manufactured in China. All rights reserved. No part of this book may be reproduced in any form or by any electronic or mechanical means including information storage and retrieval systems without permission in writing from the publisher, except by a reviewer, who may quote brief passages in a review. Published by North Light Books, an imprint of F&W Publications, Inc., 1507 Dana Avenue, Cincinnati, Ohio 45207. (800) 289-0963. First edition.

Other fine North Light Books are available from your local bookstore, art supply store or direct from the publisher.

03 02 01 00 99 5 4 3 2 1

Library of Congress Cataloging-in-Publication Data

Keys to painting: fur & feathers.
 p. cm.
 Edited by Rachel Rubin Wolf.
 Includes index.
 ISBN 0-89134-914-6 (pbk.: alk. paper)
 1. Wildlife art—Technique. I. Wolf, Rachel.
N7660.K39 1998
751.45'432—dc21

98-20240
CIP

Content editor: Michael Berger
Production editor: Nicole R. Klungle
Designer: Brian Roeth

ACKNOWLEDGMENTS

The people who deserve special thanks, and without whom this book would not have been possible, are the artists whose work appears in this book. They are:

Chris Bacon
Alan Barnard
John P. Baumlin
Terance James Bond
Paul Bosman
Cynthie Fisher
Charles Fracé
Laura Gilliland
Gary Greene
Lesley Harrison
Terry Isaac

Jay J. Johnson
Rod Lawrence
Karl Eric Leitzel
Jan Martin McGuire
Frank Mittelstadt
John P. Mullane
Claudia Nice
Danny O'Driscoll
Diane Pierce
Thomas Quinn
Judi Rideout

Michael P. Rocco
Carolyn Rochelle
Bart Rulon
Jeanne Filler Scott
Dave Sellers
Patrick Seslar
Dee Smith
John Swatsley
Bill Tilton
Persis Clayton Weirs
Eric F.J. Wilson

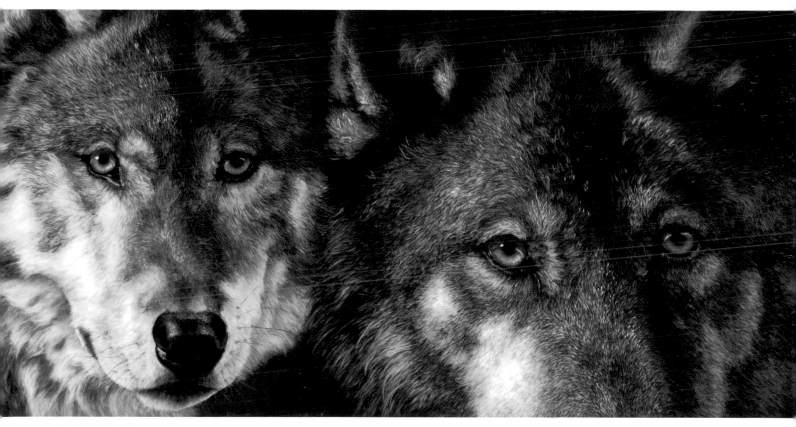

JUDI RIDEOUT
"Close Encounters" (Gray Wolves)
Soft pastel on suede mat board, 13"×28" (33cm×71cm)

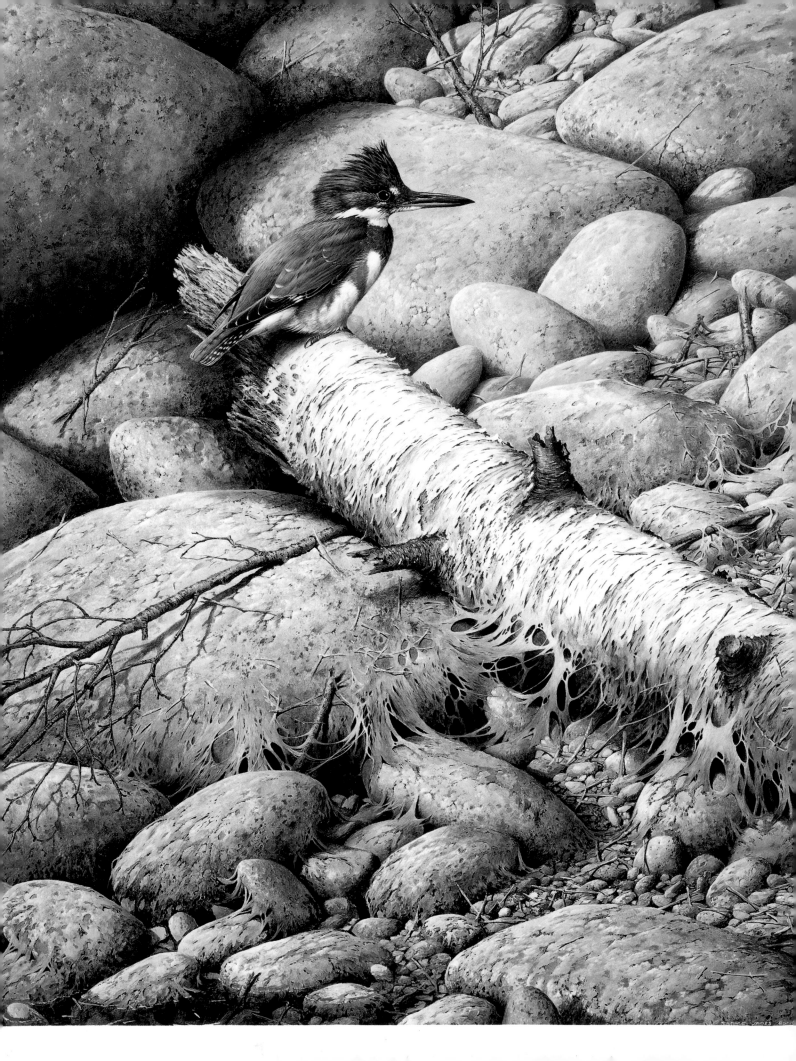

TABLE OF CONTENTS

TERANCE JAMES BOND
"Waiting for Rain" (Belted Kingfisher)
Acrylic, 30"×24" (76cm×61cm)

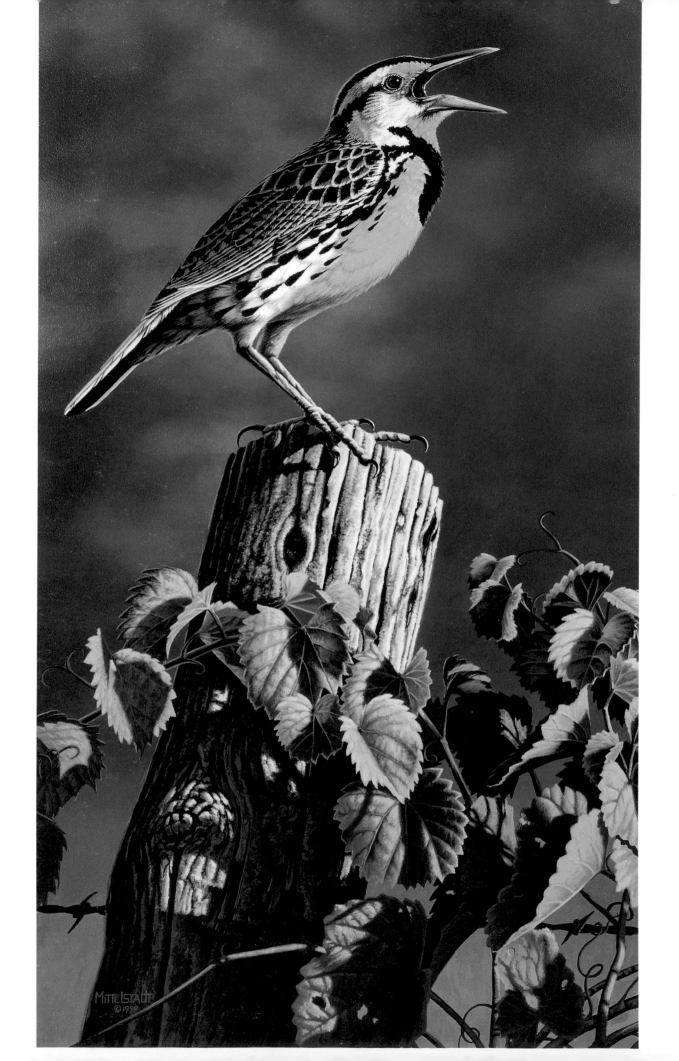

INTRODUCTION

This book is intended to be an aid to wildlife artists. We have tried to convey approaches to painting different wildlife textures in a number of popular mediums, including acrylic, oil, watercolor, ink and colored pencil. You will see complete painting demonstrations by great artists in acrylic, oil, watercolor and pastel. Each of these artists has his or her own methods, and these contribute to the artist's individual style. So keep in mind that these examples show just one particular artist's approach and may not be how *you* would paint. Thank heaven there is not just one correct way to paint!

There is much to be learned from art in all its rich and varied forms. Most of the painting styles in this book are detailed and representational. However, you may just as easily be inspired by artists who paint in broad, loose styles. Whether you are an artist or one who appreciates art, we're sure you will enjoy this book and will find in these pages something of value to you. May it increase your interest in all art and the wildlife world that surrounds us!

FRANK MITTELSTADT
"Summer Soloist—Meadowlark"
Acrylic, 24" × 14" (61cm × 36cm)

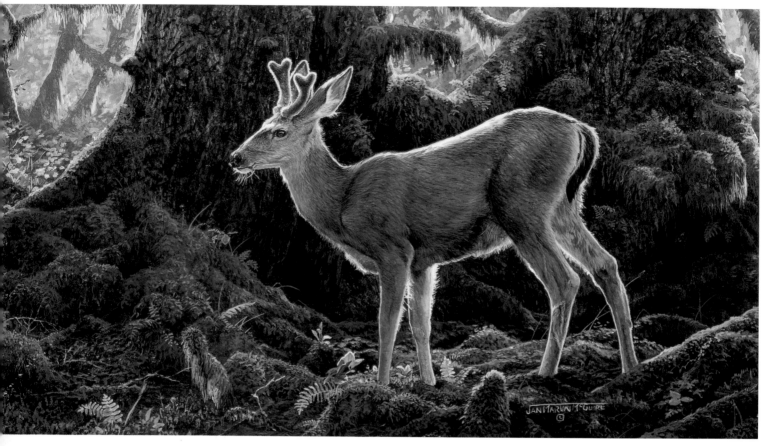

JAN MARTIN MCGUIRE
"Evenglow" (Blacktail Deer)
Acrylic on Masonite, 8" × 16" (20cm × 41cm)

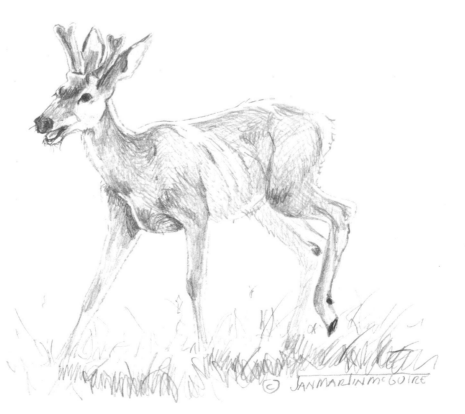

Drawing Realistic Birds and Animals

For an artist, no amount of reading or looking at other people's pictures can replace the understanding gained from watching wildlife firsthand. As you watch, take as many photos as you can. The best photographs, however, cannot substitute for sketching with your own hand. Sketching will always be one of the most useful practices in gathering references for paintings.

There are a multitude of situations where you will be able to see birds and animals but will not be able to take adequate photographs of them. You might see something unexpected happen in a split second, or observe a bird through binoculars or a spotting scope. In these cases, sketching will be the best recording tool. Sometimes you have to rely totally on memory, but it's always more desirable to go back home with an idea sketched on paper than to return empty-handed.

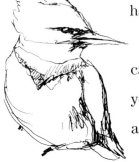

Sketching will ultimately teach more than snapping a picture because it requires assimilating lots of information. The visual knowledge you amass about a bird or other animal by drawing it over and over again will increase your drawing ability over time.

Start Drawing From Simple Shapes

BILL TILTON

The drawings by Bill Tilton on the next twelve pages are offered as examples of drawing animals from simple shapes. If you like, take your time and copy the drawings in this section for practice.

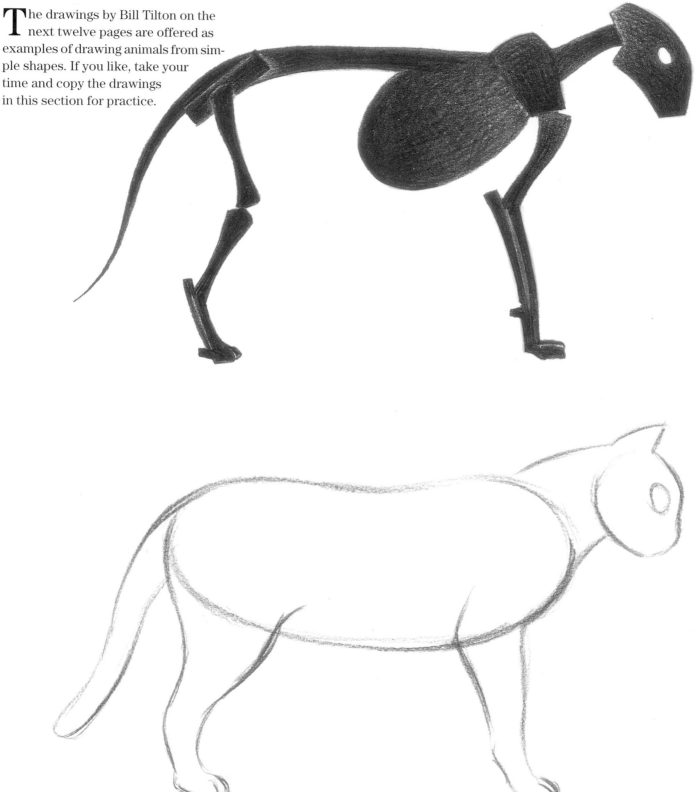

Basic Cat Shapes

The drawing at the top shows a simplified cat skeleton. The drawing above shows the cat body as a simple peanut shape.

Refining the Cat

After erasing unwanted lines, begin to add stripes with a pattern of careful, short strokes. Notice how the angle of the stripes follows the lay of the fur and the curves of the cat's body, suggesting mass.

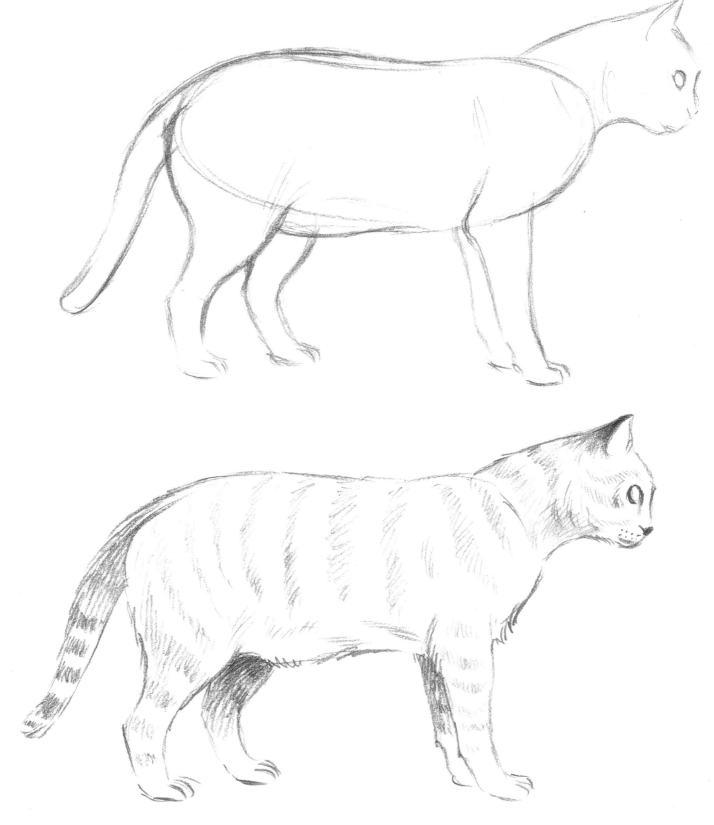

Drawing a Cat in Charcoal

Even if you are a beginner, you can successfully reproduce this large charcoal drawing of a cat (opposite page). The drawing is composed entirely of a series of soft strokes with a General 6B charcoal pencil. Rub the strokes together to make them look smooth, adding more strokes when you want an area or certain details darker. When satisfied, spray fixative on the sketch and let it dry. Finally, add some strokes of white acrylic for whiskers and for some body hairs crossing dark areas.

Cat Sketches
Here are some quick gestures of a cat and kitten. The large sketch is the foundation for the charcoal drawing at right.

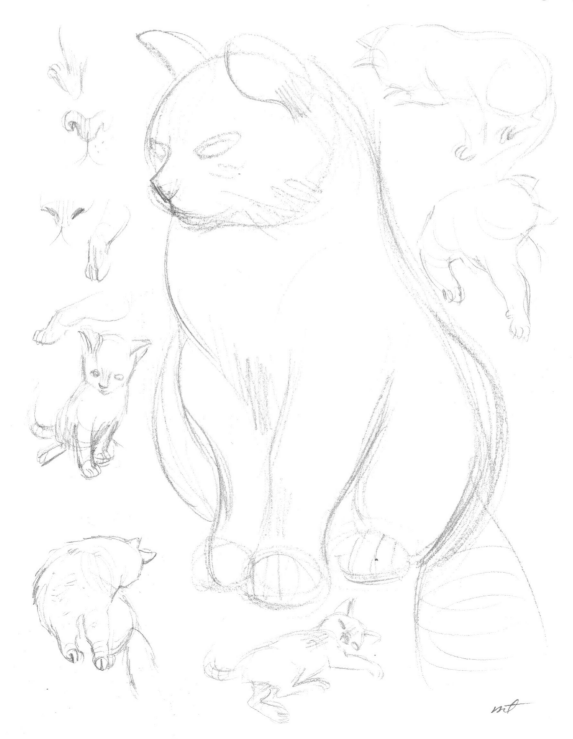

Refining the Cat
Using a 6B charcoal pencil, sketch in the direction of the fur, using light pressure for the lightest gray areas and a firmer, more layered stroke in the dark areas. Then carefully blend the strokes with your finger or a soft cloth on a blending stick, and re-darken any details you wish to emphasize.

Drawing a Squirrel

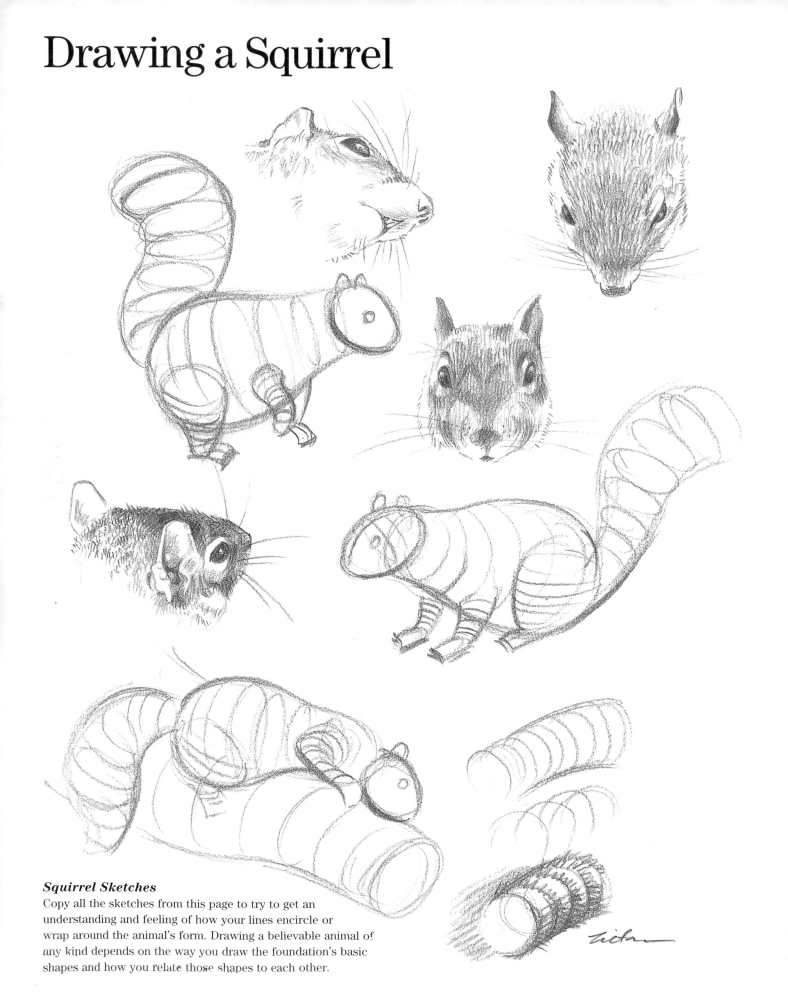

Squirrel Sketches
Copy all the sketches from this page to try to get an understanding and feeling of how your lines encircle or wrap around the animal's form. Drawing a believable animal of any kind depends on the way you draw the foundation's basic shapes and how you relate those shapes to each other.

Refining the Squirrel

With the pencil drawing complete, lightly fix it, then add very little watercolor, using a no. 6 round watercolor brush. To make the bark and lichen look realistic, add white gouache to the watercolor; the result will be an opaque color.

Drawing a Lion's Head

Lion's Head Sketches

Even when concentrating on one enlarged area of an animal, such as this lion's head, you can still break the drawing into its basic foundation shapes. Positioning these shapes correctly in respect to each other is the key to producing a recognizable animal drawing. Note how the planes of this lion's head have been divided, making a guide for the placement of muzzle and eyes.

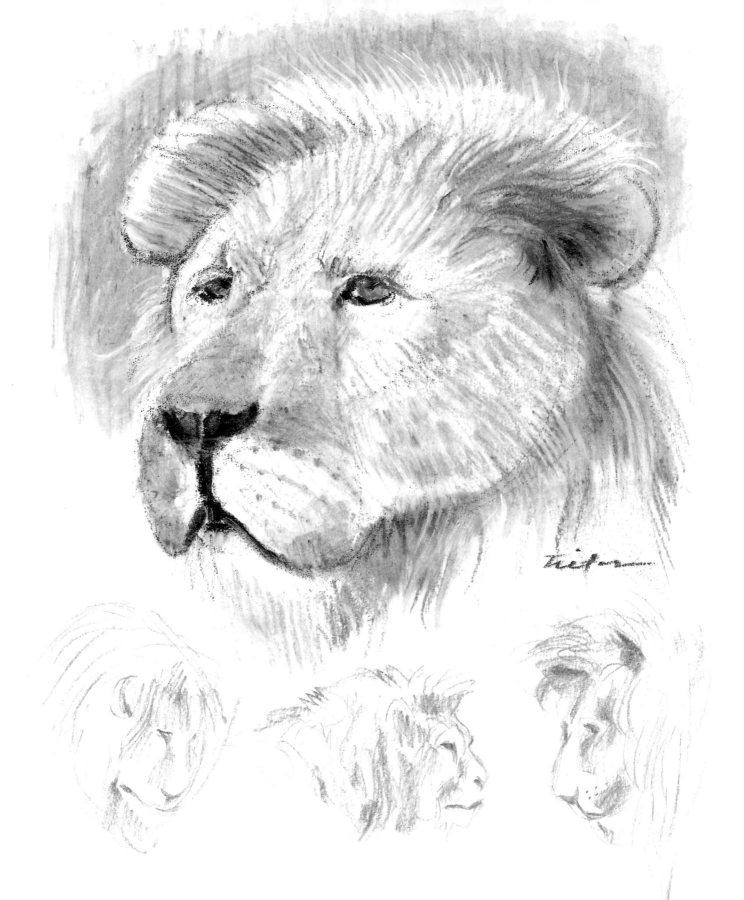

Refining the Lion's Head

To share the challenge of working in an unfamiliar medium, Bill Tilton decided to
finish his lion's head in oil pastels. Use these pastels as you would ordinary crayons.
Blend colors easily using a bristle filbert and mineral spirits, a good solvent for
both crayons and oil pastels.

Drawing a Heron

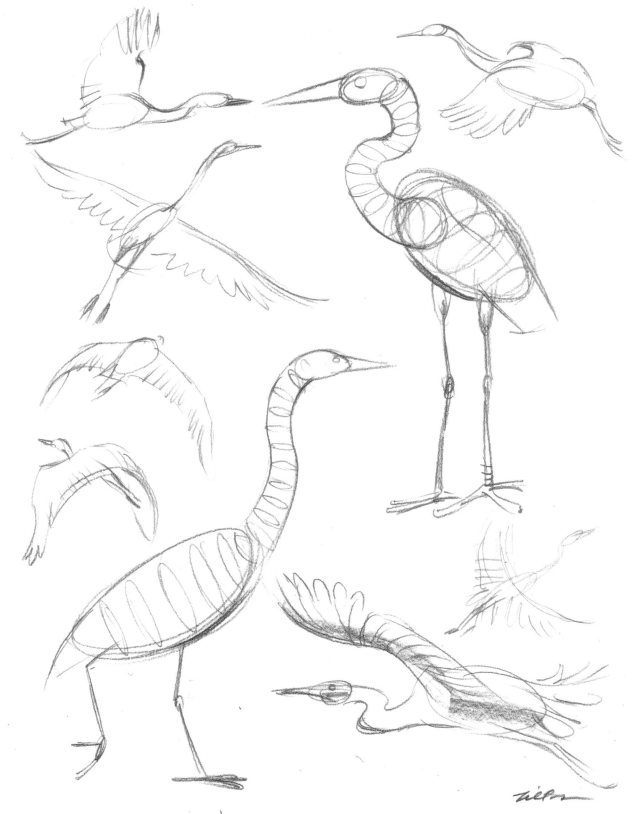

Heron Sketches

Two better-known members of the heron family are shown here: the great egret
and the great blue heron. They are actually easy to draw with their football-shaped
bodies and long columnar necks.

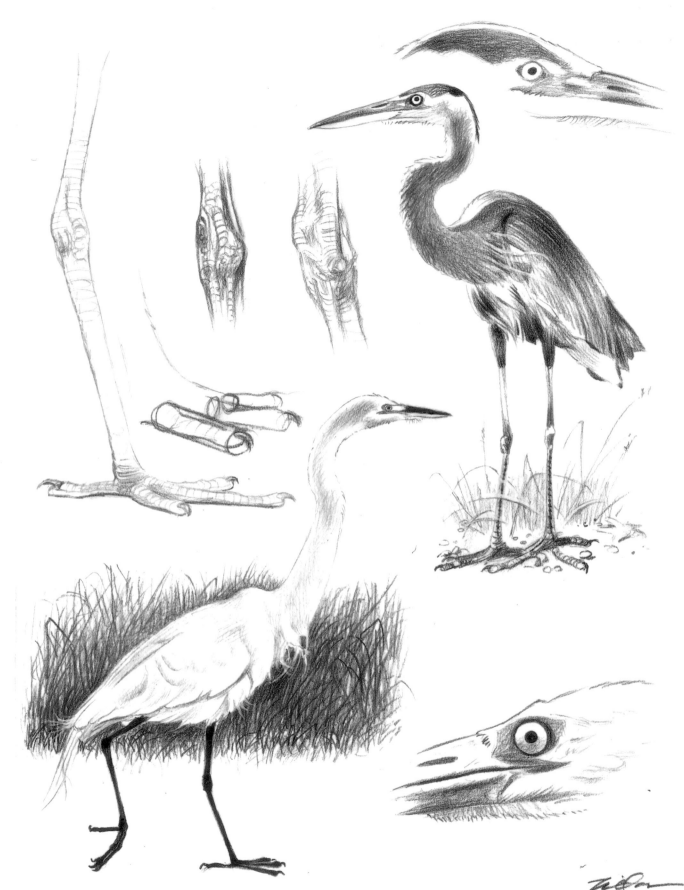

Refining the Heron

Once you have established the masses that make these birds distinctive, study their plumage carefully and try to establish each bird's distinct look using a minimum of detail. Keep your feathering as simple as you can; highlighting a few select shafts and vanes conveys the idea of feathers.

Drawing a Deer

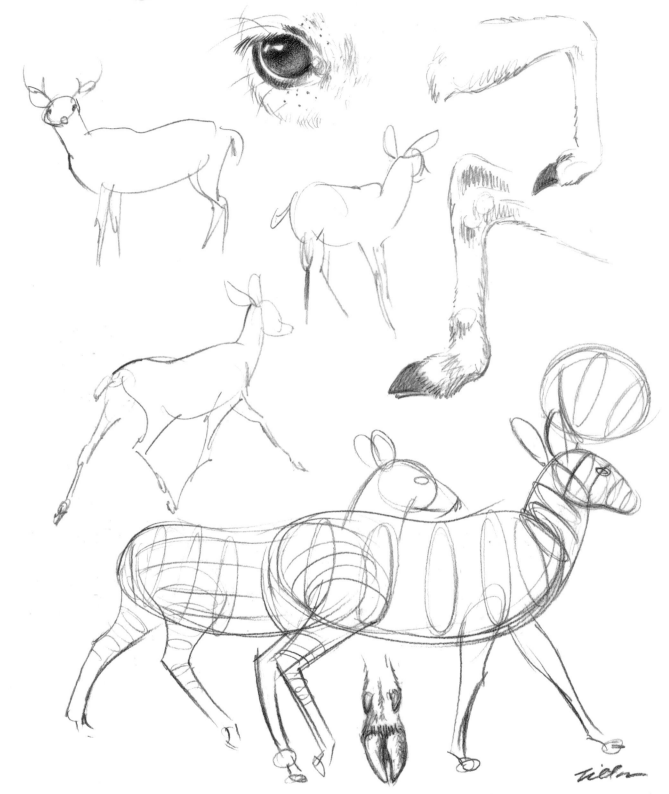

Deer Sketches

Bill Tilton had seen so many drawings of the handsome white-tailed deer that he decided to portray instead the kind he grew up with in Wyoming and Colorado, the mule deer, so named because of its large ears. Note particularly this easy way to draw antlers. Think of the antler rack as a cantaloupe-like globe, and use that structure to draw this seemingly complex feature.

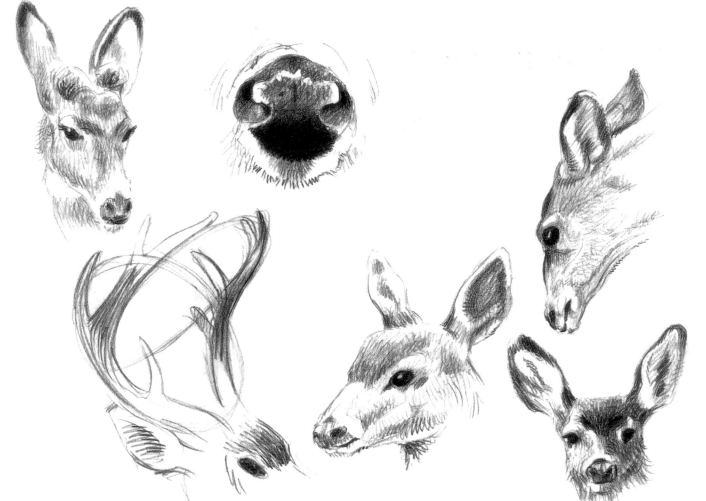

Refining the Deer

Once you've mastered the basic shape of these mule deer, you should be able to draw any of the different deer varieties. Simply consult one of the many wildlife references available at most libraries or bookstores, and make detailed notes and sketches of those features unique to each type of deer, such as the size of the ears on these mule deer. Tilton's sketches come from over two hundred close-up photos he has taken over the years on the grounds of the U.S. Air Force Academy, where mule deer are abundant.

Sketching From Life

Ⅰt is important to draw birds from life. But it can be very intimidating to draw a bird that not only won't stand still, but is moving rather quickly. One of the biggest obstacles to overcome in sketching is the fear of failure. To overcome this fear, think of your sketchbooks as a private library. You don't have to show the results of your sketches to anyone. This keeps your attention on drawing as quickly as possible, rather than on tediously making a drawing to try to impress someone.

Sketches can be used to understand what red-breasted mergansers look like immediately after surfacing from a dive, and how their heads look as they turn.

OBSERVING

Before sketching, observe the bird without drawing. Pay attention to anatomy, contour, gesture and detail. Note how the bird's parts relate to each other. Record shapes, sizes, angles, proportions and placement of head, beak, body, tail and legs. A sketch may often illustrate just one of these areas, but purposes can be combined.

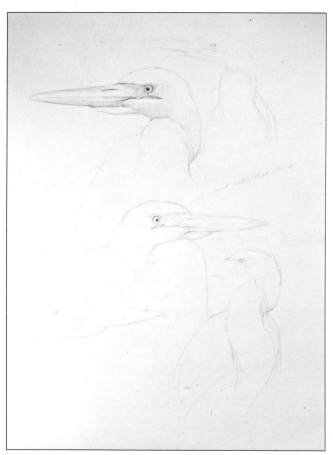

JOHN P. BAUMLIN, *"Egret Sketches." Pencil.*

Sketching for Gesture

In these sketches you can see clearly how the shape and angles of the neck change when the egret moves its head.

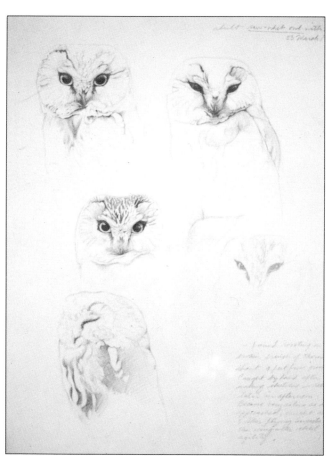

JOHN P. BAUMLIN, *"Saw-Whet Owl Sketches." Pencil, 14"×11" (36cm×28cm).*

Sketching for Details

These sketches record feather details, especially around the owl's head.

Loose Gesture Sketches

Gesture involves the position of a bird as it moves. Sketches should be very loose and quick, with few details. Sketch each different pose as long as it is held. Ask yourself the same kinds of questions as when observing, beginning with major relationships.

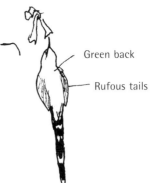

Green back

Rufous tails

Sometimes it will feed on a flower while perched on a branch.

This bird often flicks its tail up and down.

The most noticeable thing about this black-tailed trainbearer (a tropical hummingbird) is its extremely long tail, which appears to be a few inches longer than its body. The bill is fairly short and skinny, and the legs are tucked into the lower belly feathers so that only the feet are visible. Remember the kinds of things you should look for when doing a gesture sketch.

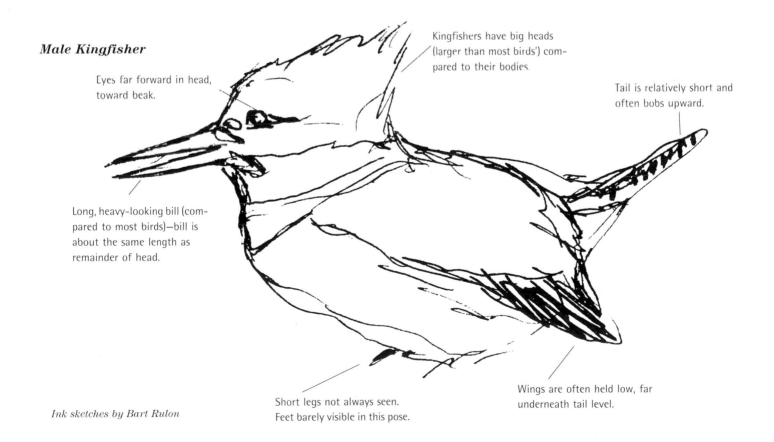

Male Kingfisher

Eyes far forward in head, toward beak.

Kingfishers have big heads (larger than most birds') compared to their bodies.

Tail is relatively short and often bobs upward.

Long, heavy-looking bill (compared to most birds)—bill is about the same length as remainder of head.

Short legs not always seen. Feet barely visible in this pose.

Wings are often held low, far underneath tail level.

Ink sketches by Bart Rulon

Quick Contour Sketches

Quickly rendering only the general outlines of a subject—without worrying about precision—not only helps you warm up, but also builds confidence in going directly from sight to sketch pad. Speed is the key. Just draw quickly, without looking down at your sketch. Trust your hand to capture the gesture.

The contour sketch is valuable for capturing movement because it is quick and provides an instant, loose approximation of an action or interesting behavior.

Corner of mouth extends below eye.

Heron dips forward while swallowing, causing tail to rise above level of neck and breast.

Neck expands directly behind base of bill as heron swallows its meal.

While walking, its legs spread. One is directly under the body for support and balance as the other leg lifts up.

Great Blue Heron

Body angles upward from tail to head at about 30°.

Notice how the large neck bend looks in comparison to the upper neck.

Legs
Pay special attention to the length and movements of the legs when sketching long-legged wading birds such as this great blue heron.

Unique Markings
Characteristic marks under the tail—as well as on breast, head and flanks—are very important in depicting the male green-winged teal.

Green-Winged Teal

Black marking underneath tail from different angles.

Knowing such details as where the white vertical side bars are before starting to sketch helps you notice how they curve with the body during a head-on view.

Sketching for Detail

Details are smaller, more particular parts of the bird. If your purpose is recording minute feather patterns, concentrate on that area even if you must leave other areas incomplete. It's better to draw only what you directly observe. If you don't have enough time to observe all of the details, don't put them in; to do so would invite mistakes. A very simple, correct sketch is better than a very detailed sketch of questionable accuracy.

NOTE FEATHER MARKINGS

Feather markings are an important means of bird identification. Note major plumage first, then look at smaller details. This teaches visual facts for accurate rendering. Some questions to ask about distinguishing characteristics include:

- Does the bird have wing bars?
- Is the breast streaked?
- Are there any markings on the tail?

Male Kingfisher
These are the kinds of feather notations Bart Rulon would make on this kingfisher sketch.

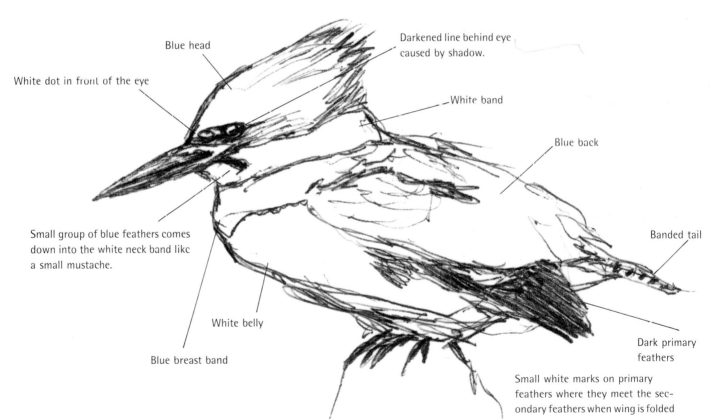

Blue head

Darkened line behind eye caused by shadow.

White dot in front of the eye

White band

Blue back

Small group of blue feathers comes down into the white neck band like a small mustache.

Banded tail

White belly

Blue breast band

Dark primary feathers

Small white marks on primary feathers where they meet the secondary feathers when wing is folded

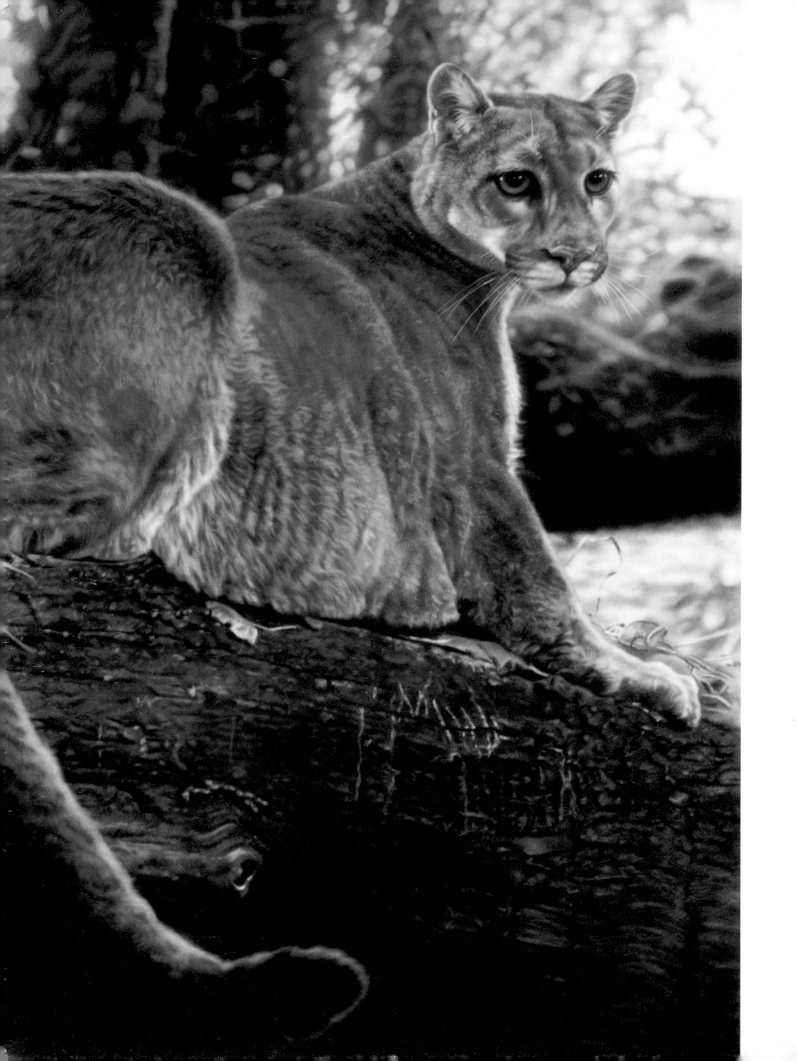

Painting Fur Textures

Fur can be defined simply as the hairy coat grown by mammals. It provides many major functions for these animals. This covering of hair keeps some animals warm under harsh, cold conditions by acting as natural insulation. Yet it helps others stay cool in extremely hot climates. Fur can keep some animals waterproof and buoyant, and can aid in the drying process by shedding water. It offers some protection from insects and brush, and serves as camouflage from predators through the use of color and pattern. Fur color and composition can even change with the seasons to help the animal adjust more comfortably to seasonal environmental changes.

The variety of fur is just as fascinating as its functions. There are so many types of hair—thick and thin, long and short, curly and straight. The colors and patterns are richly varied.

All these characteristics can be quite a challenge to the wildlife artist. Even so, you can use certain basic techniques to produce a realistic likeness of fur or hair. On the following pages are lessons and step-by-step demonstrations that will show you how to paint several distinctly different types of fur.

LESLEY HARRISON
"Woodland Royalty" (Mountain Lion)
Pastel, 25" × 17" (64cm × 43cm)

Painting the Textures of Wolf Fur

PERSIS CLAYTON WEIRS

Wolves have two basic types of hair in their coat: a fine, soft undercoat made up of dense, shorter hair that is generally lighter and relatively uniform in color; and an outer layer of guard hairs that are longer, coarser and more colorful than the undercoat. The undercoat's primary purpose is to provide winter insulation in the subzero habitat of the gray wolf. Most of the undercoat is shed when warmer spring weather returns, leaving the wolf with a much thinner coat and a leaner appearance in summer. The undercoat grows back in the fall. The outer coat (made up of guard hairs that typically grade in color from white at their base to black or brown at their tips) is more permanent, tougher, and more resistant to weather, wear and dirt. A wolf's overall color pattern is determined by its guard hair.

Area included in wolf fur demonstration

1 Although wolves' coats come in all shades of gray from black to white, the area near where the wolf's neck and shoulder meet shows the most variation in direction, length, texture and color shading.

First, underpaint with a mixture of Raw Umber and Ultramarine Blue, using strokes consistent with the length and direction of the hair. Then work outward from dark to light before adding shadowing in the lighter undercoat to give depth to the fur.

2 Next, thicken the hair with white and Raw Sienna, overlapping your strokes to develop the appearance of dense fur. To texture the fur, double-load a no. 0 round brush with white and Mars Yellow on the left side and Raw Sienna and Raw Umber on the right, adding more white to the combination as you work toward the lighter chest area. In lighter areas, enhance the texture by using Raw Umber to separate the fur and "sink" the fur in some areas with graded shadows.

3 Make certain that the guard hairs are longer and rather grizzled-looking where the neck joins the shoulder. Below this, make the fur on the shoulder shorter and somewhat tufted in appearance. Then refine the colors further so the coat transitions smoothly into a creamy white at the chest.

Finally, heighten the shaggy look of the wolf's coat by adding black tips to some of the guard hairs near the top of the shoulder, and lift individual hair tips by highlighting them with white (followed with a light glaze of Raw Sienna to moderate the otherwise rather dead white).

Top of shoulder

Fur texture changes from here down diagonally at the base of the neck.

Lighter chest area (below the point of the shoulder)

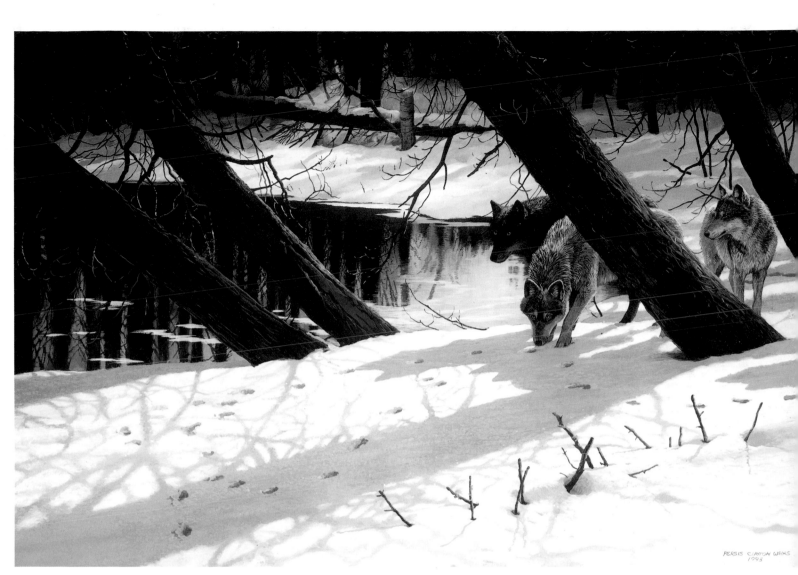

PERSIS CLAYTON WEIRS
"Moon Shadows" (Gray Wolves)
Acrylic, 24" × 26" (61cm × 66cm)
Courtesy of the artist and Wild Wings, Inc.

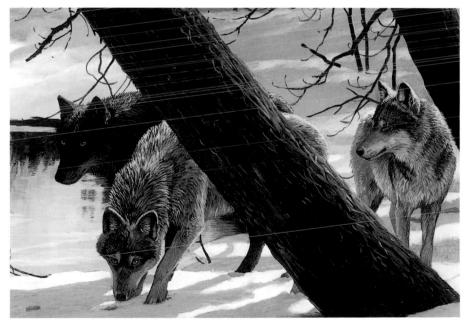

Detail

Frozen Fur
This painting depicts how ice and snow cause the outer guard hairs of a wolf to freeze together into thick, separated spikes.

Rendering Wet Fur on Aquatic Mammals

PERSIS CLAYTON WEIRS

The soft, dense fur of aquatic mammals such as otters, minks and beavers takes on an entirely different appearance once the animal enters the water and its fur becomes wet. For example, on an otter's neck and chest the undercoat, when dry, appears rather dark in relation to the outer fur, but when the outer coat gets wet, the undercoat revealed between the wetted "spikes" of outer fur suddenly appears much lighter.

Location of wet otter fur demonstration

1 Begin by underpainting the area in a soft neutral brown using a mixture of Raw Umber, Burnt Umber and white, lightening the color as you approach the front of the neck. Using a no. 0 round brush, carefully place each stroke to follow the length and direction of the fur.

2 Next, in the darker area, use a mixture of black and Burnt Umber to separate the fur into spikes that form when wet guard hairs cling together. For the lighter area, use a mixture of Raw Umber and Ultramarine Blue to sketch in the spikes of wet fur.

3 To complete the wet fur texture, highlight the tips in the lighter fur with white and Raw Sienna and then add detail to the side of each wet spike, using darker mixtures to indicate hairs drawing together to form each spike. In the darker fur, highlight the shiny spikes of wet fur with sky light, using a mixture of white and Ultramarine Blue. Finally, add glints of pure white to give the fur a freshly wetted look.

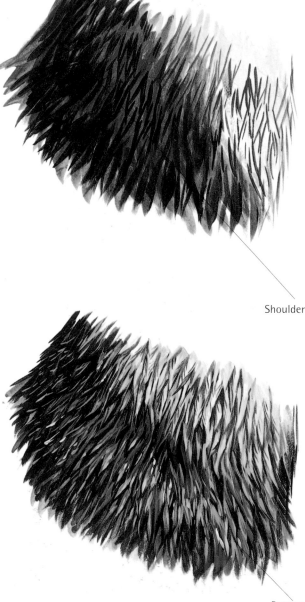

Front of the neck

Shoulder

Bottom

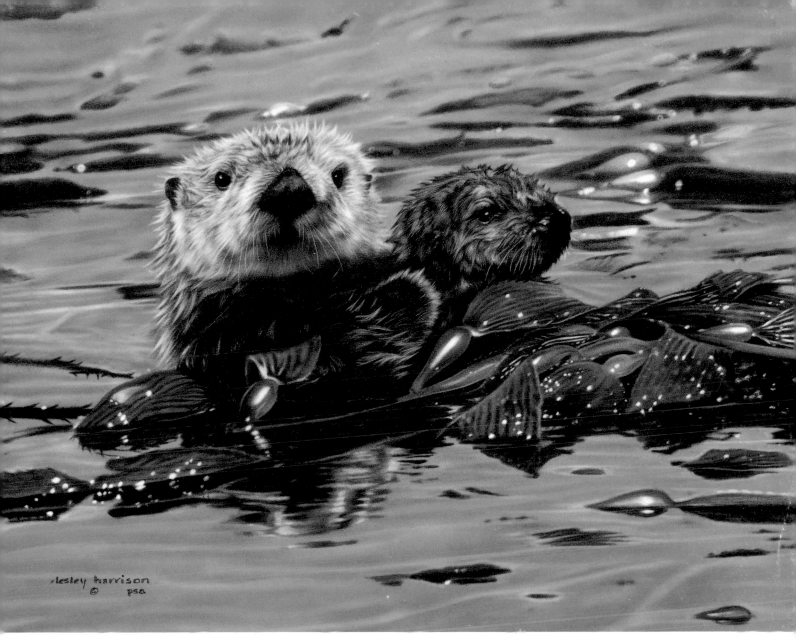

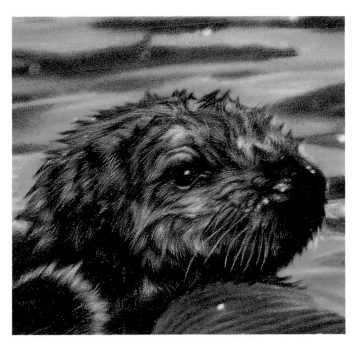

LESLEY HARRISON
"In Our Care" (Sea Otters)
Pastel, 16″ × 20″ (41cm × 51cm)

Sea otters do not have a layer of fat below the skin, so they rely on air trapped in their very dense, soft fur to protect them from cold water.

Detail

Capturing the Play of Light on White Fur

PERSIS CLAYTON WEIRS

Many wildlife species such as polar bears, arctic foxes, harp seal pups and arctic wolves have thick, white fur that changes dramatically under different lighting conditions. This demonstration shows how to paint the effect of bright, low sunlight on the foreleg of a polar bear.

Location of polar bear
fur demonstration

1 Begin by underpainting the blue edge of the shadowed side to indicate the effect of reflected sky light. Toward the front of the leg, where it's possible to see into the fur, underpaint by adding Raw Umber to the blue used previously. On the sunlit side of the leg, underpaint with a mixture of white, Raw Sienna and Mars Yellow to bathe the white fur in the golden glow of the sun (although polar bear fur sometimes has a yellowish tint of its own).

2 To give the fur a denser appearance, add several more layers using short brushstrokes and the same colors as in step one. Don't mix these colors on the palette; instead, dip the brush into each color separately to allow individual hairs to appear.

3 To complete the fur, add white highlights along the edges of the darker areas to give a greater feeling of depth and to indicate sun glistening off the guard hairs.

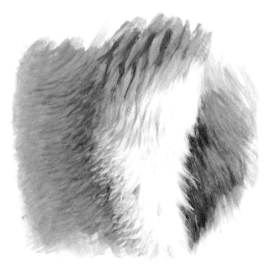

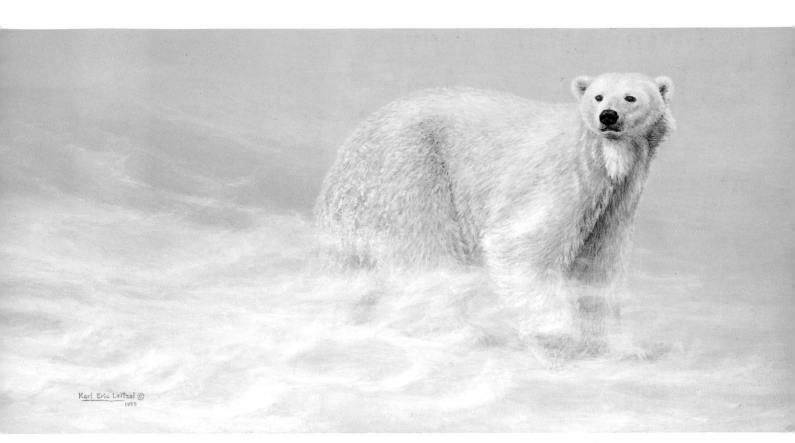

KARL ERIC LEITZEL
"Great White Hunter" (Polar Bear)
Acrylic, 12" × 24" (30cm × 61cm)
Collection of Larry J. Selfe

A polar bear's fur is composed of long, coarse outer hair combined with a very dense undercoat.

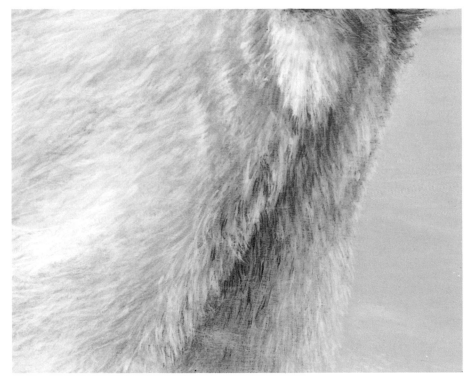

Detail

Painting Black Fur in Acrylic

ROD LAWRENCE

1 This is the left front foot of a black bear. Start with a medium to dark value and paint the entire foot except for the claws. The first layer is semitransparent, as on the left side. The overlapping paint strokes already suggest hair clumps. Keep the brushstrokes in the direction of the fur. Continue with a more opaque surface. The right side of this foot shows two or three coats of paint, with which you will cover the rest of the foot. Fill in the claws with one application of paint.

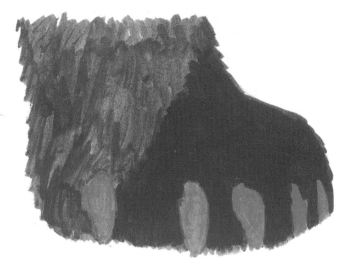

2 Mix a fairly dark value, but still light enough that the final dark will contrast with it. Check this by making a paint swatch of the two colors, so you can check the value difference between them. With this, begin painting the shadowed areas of the foot. Notice how to suggest the claws and toes under the fur with the dark paint. This helps establish a space between each toe and follows the flow of hair. Add both a darker and lighter value on the claws to start building some form.

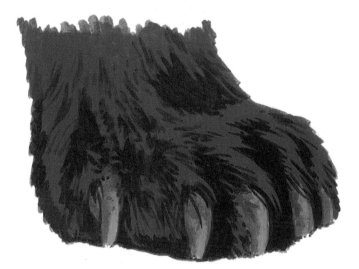

3 The final dark paint is Ultramarine Blue and Burnt Umber. Use this to make the shadows recede more and accent some of the fur. Mixing Cadmium-Barium Red Deep, white and Cerulean Blue with the base color gives you a lighter value to begin adding highlights to the top of the toes. Lighten this with white in several steps and apply glazes to build highlights on the fur clumps. The claws are worked in a similar way, except use Burnt Umber and Yellow Ochre to keep the color correct.

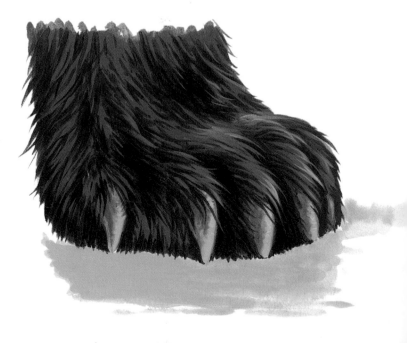

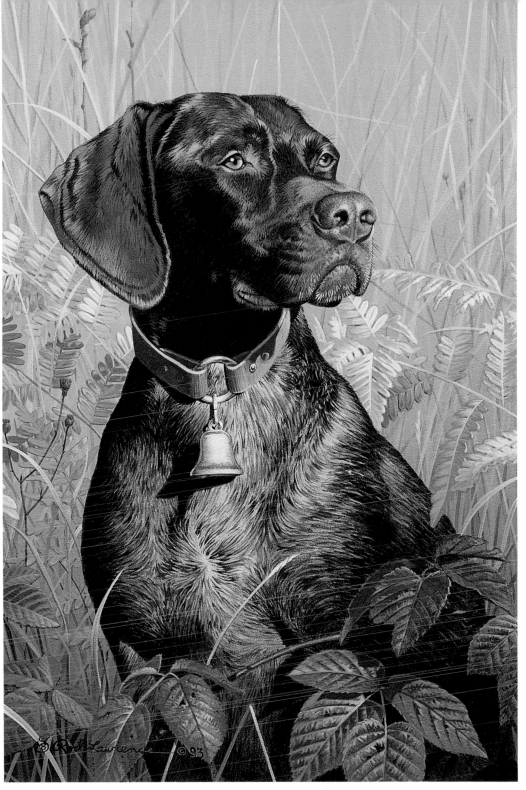

ROD LAWRENCE
*"Walter" (German Short-
Haired Pointer)*
Acrylic, 9" × 13" (23cm × 33cm)
Collection of Dr. Norman Licht

Dogs are not what some would consider "wildlife." Nonetheless, pets can be great subjects for drawing and painting. Locating a black bear or black panther to study and paint can be difficult. Finding a black house cat, horse or Labrador retriever can be relatively easy. They all present the same challenge in painting a very dark creature. Black or really dark subjects reflect a small amount of light and have no predominant color hue. This painting of a German short-haired pointer, a good example of a black animal subject, shows how the bright sun reflects off the hair and head structure to produce highlights. In low-light conditions, use some artistic license to emphasize the reflected light.

Painting Dense Grizzly Bear Fur

When you're painting wildlife, it's relatively easy to capture readily observable anatomical features that differentiate one species from another. To paint truly credible images, however, you must also understand and be able to paint the subtle features of an animal's coat—not only what it looks like, but how (or even if) its color and texture change with season or habitat.

An animal's coat is composed of either hair or fur, but when it comes to rendering the resulting textures, such distinctions may not be especially significant. Regardless of the term you use, fur textures and colors vary widely between different species, and even within the same species. Look at this painting by Charles Fracé. Notice how grizzly fur is dense and coarse as compared to the softer fur you would find on smaller mammals.

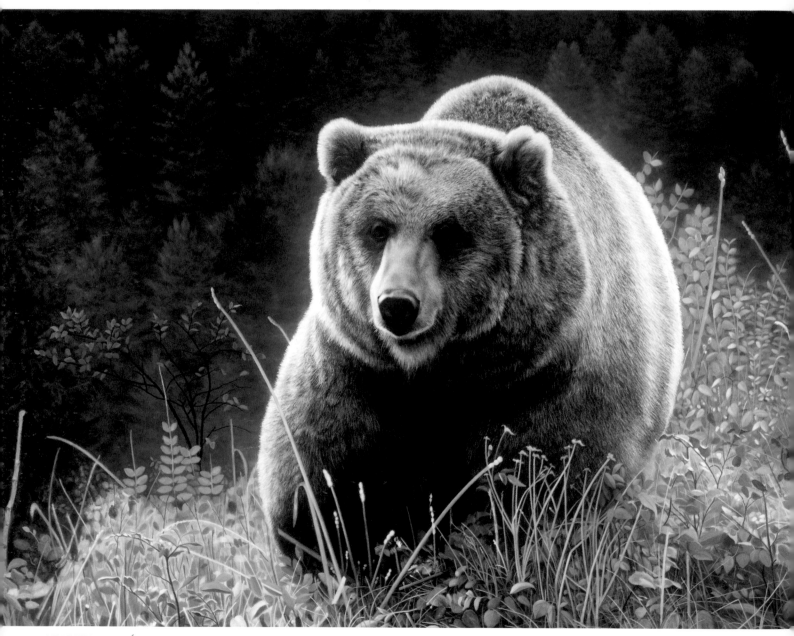

CHARLES FRACÉ, *"Unrivaled" (Grizzly Bear). Oil on canvas, 38"×50" (97cm×127cm)*

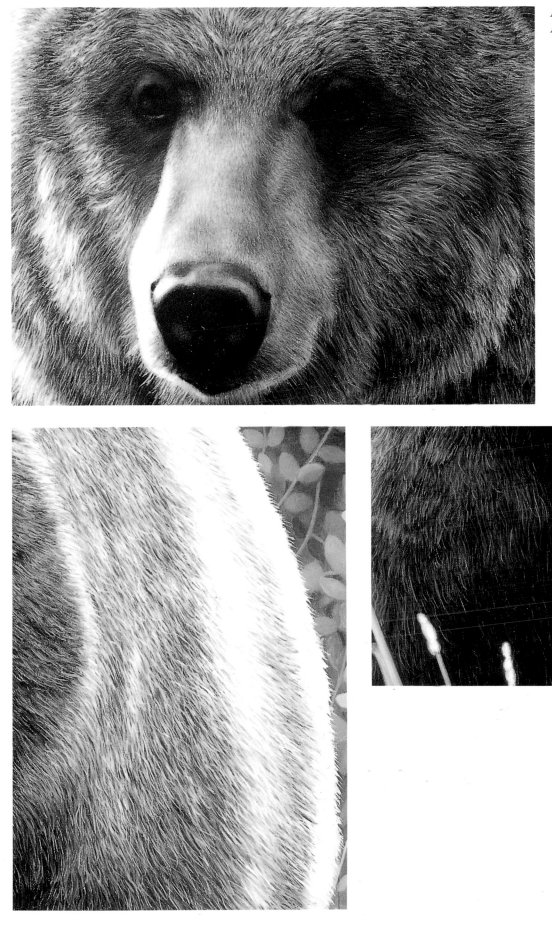

Painting Long Fur in Acrylic
American Elk

R O D L A W R E N C E

1 The circle shows the area of the elk used for this demonstration. This is the fur of a bull elk in late fall when the hair is long. In this area of the body it is sometimes thick and clumped together. Start the painting with a middle value for an opaque base. Then use some pencil lines to help in planning the basic fur structure.

2 Add shapes in a slightly darker value, using your pencil as a guide. These darker areas contrast with the base color, allowing shadows and clumps of fur to show up nicely without being too strong yet. Major fur areas are now defined according to the elk's anatomy.

3 Now, use subtle contrast changes to add more detail and further define the long strands of hair. Add both some lighter tones and small areas of darks. These changes in value are what create the look of the fur texture. As you paint, keep thinking of how long hair tangles together and try to convey that in the painting.

4 The last values of lightest lights and darkest darks are applied to the overall fur pattern. The dark values help pull you into the shadow depths. The light values should bring the highlighted fur out of the picture. This should achieve the three-dimensional look of long fur. The fur strokes in the lighter area stay subtle to keep that area light in value.

Painting Curly Fur in Watercolor
American Bison

ROD LAWRENCE

1 For bison fur, start with a few color washes of light to medium values. These help establish preliminary color areas. Begin by premixing the colors you intend to use on this step, then wet the area so the colors will flow in a wet-into-wet technique. With your layout drawing on tracing paper, you can transfer some key lines back over the painting when it is dry.

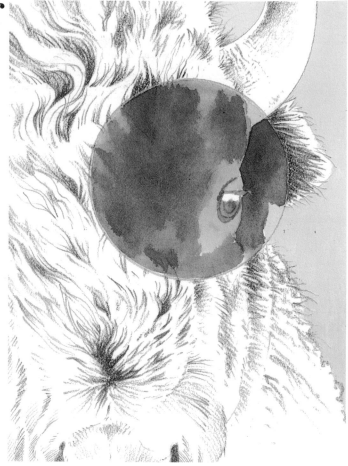

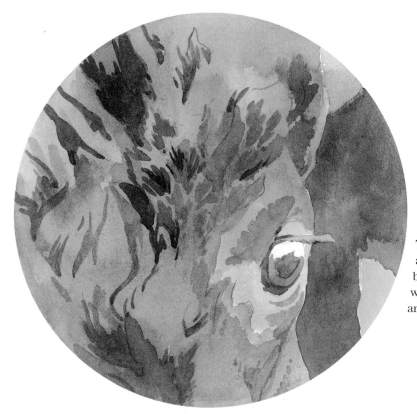

2 Use the transferred pencil lines as guides in applying some deeper colors to define the hair shapes. Slowly build contrast to show form and depth. This step is a good start toward that end and helps you understand the fur areas better as you paint. When working with watercolor, always try to keep the light areas from getting too dark too soon.

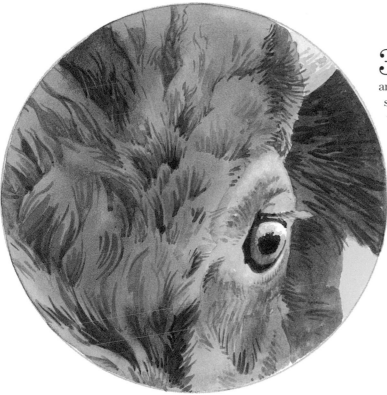

3 Continue adding more dark values to build forms. Details can be added and the contrasts between light and shadow become stronger. Subtle color washes are used to insert color changes where they are needed. These areas will be reworked in the last step.

4 The final phase is often the fun phase. Now you can add the final details. The addition of the final darkest values really brings out the forms and ties the painting together. You can still wet and blot areas to lighten them if necessary.

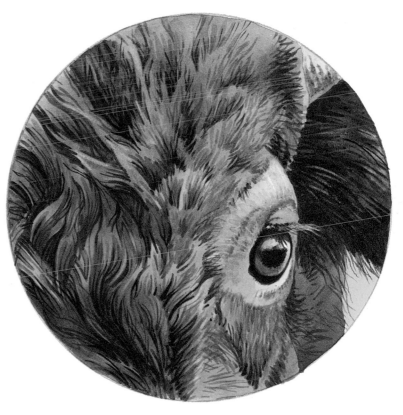

Painting Fur Patterns in Acrylic
Snow Leopard Cub

R O D L A W R E N C E

1 To paint most fur patterns, start with a flat, opaque background of medium-value color. Using a transfer sheet, put the major lines for the fur pattern from your layout drawing onto the dry paint. Using a somewhat worn no. 2 round brush, begin painting some fur markings according to your drawing and reference material. Use paint that is the consistency of runny toothpaste or even thinner.

Always keep in mind the texture you are painting—in this case, the short, dense fur of a cold-weather mammal, a very young snow leopard cub. Thin washes of either dark or light values can create interesting areas of semitransparent paint. Later, these can be accented to look like small clumps of fur.

2 In addition to the larger dark pattern areas, begin to add the small shadows in the lighter fur clumps. This is not a really dark value contrast, but enough contrast to show up well. Then take a lighter value color and begin to paint the lighter areas of fur. Paint this lighter tone mainly on the upper portion to indicate light striking the higher and more prominent areas of fur.

3 Now mix up both darker and lighter value colors. With these mixtures you can put in more detail and continue to build the illusion of depth and put more emphasis on light and shadow. At this time also use some thin washes to lighten small areas of fur in the middle of the dark fur spots. By now, you should be able to tell which areas are working well for you and which areas you need to work on to get a better fur "feeling."

4 Time to make the fur really stand out. To get the feeling of depth, use your final dark and light to play up the shadows and highlights, adding yet another layer of value changes. This layering is the secret to creating the "fluffy" feel of fur. You can also put in a few individual hairs to further enhance the texture. If you are successful, the completed painting has the look and to the viewer's eye has the "feel" of the young snow leopard's thick fur.

Paintings With Patterned Fur

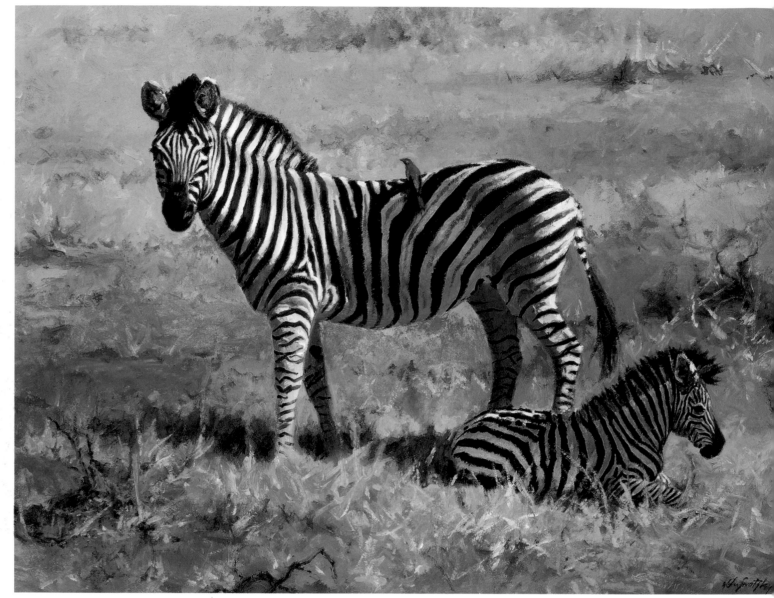

DIRECT ATTENTION WITH A SIMPLE BACKGROUND

An animal mother's concern for and protection of her young is an accepted fact of nature. However, on the African savannas it is absolutely essential. Frequently preyed upon by lions, hyenas and wild dogs, the zebra mare uses vigilance and keen eyesight to provide an early warning system for her foal. This piece shows the sensitive link between the two while hinting at the underlying tension felt in the African wilds. Artist John Swatsley originally observed this pair in Zimbabwe in the semiopen woodland of Mopane scrub. And though it was a pleasant scene, he felt that the solitude and vulnerability of their situation would be better shown by placing them in an open setting. To direct the viewer's attention to the pair without distractions, Swatsley used a simple background of soft-focus bands of grass and bare ground. Horizontal shapes project a calm mood in any composition. The circle of grass tufts in the background helps to move the eye around the painting and back to the figures.

JOHN SWATSLEY, *"Mare and Foal"* (Burchell's Zebra). Oil, 22"×30" (56cm×76cm)

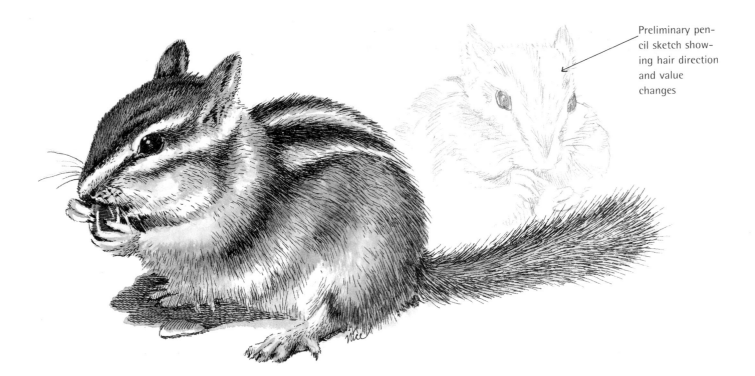

Preliminary pencil sketch showing hair direction and value changes

Spots and stripes (occur where dark and light hairs meet a transition zone of mixed values)

Speckled fur (flecks of dark hair mingled with light)

Dapples (patches of hair color that vary slightly in value)

The spotted and striped coats of the animals on this page were depicted in pen and ink (3×0 nib size). Then they were tinted with watercolor, and the final touches were stroked on with a no. 4 round detail brush using dry-brush techniques.

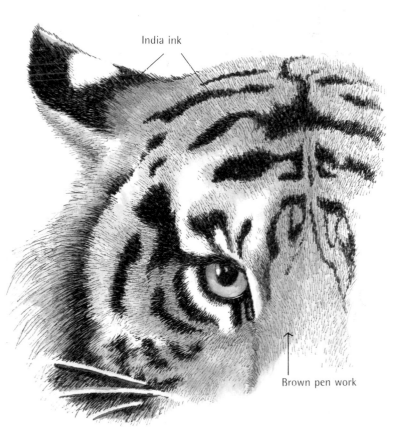

India ink

Brown pen work

At a distance, individual hairs are not seen. Use watercolor washes, lightly shaded with drybrushing and contour pen lines, to suggest the coat.

Blotted highlights add a satin sheen to the dark hair areas.

Long crisscross ink lines

On a black coat, pen lines are moved closer together, filling in almost solid in the shadows.

Washes of Payne's Gray deepen the value and add a rich blue-black sheen.

Unpainted areas suggest the light reflecting off a healthy, glossy coat.

Wavy ink lines

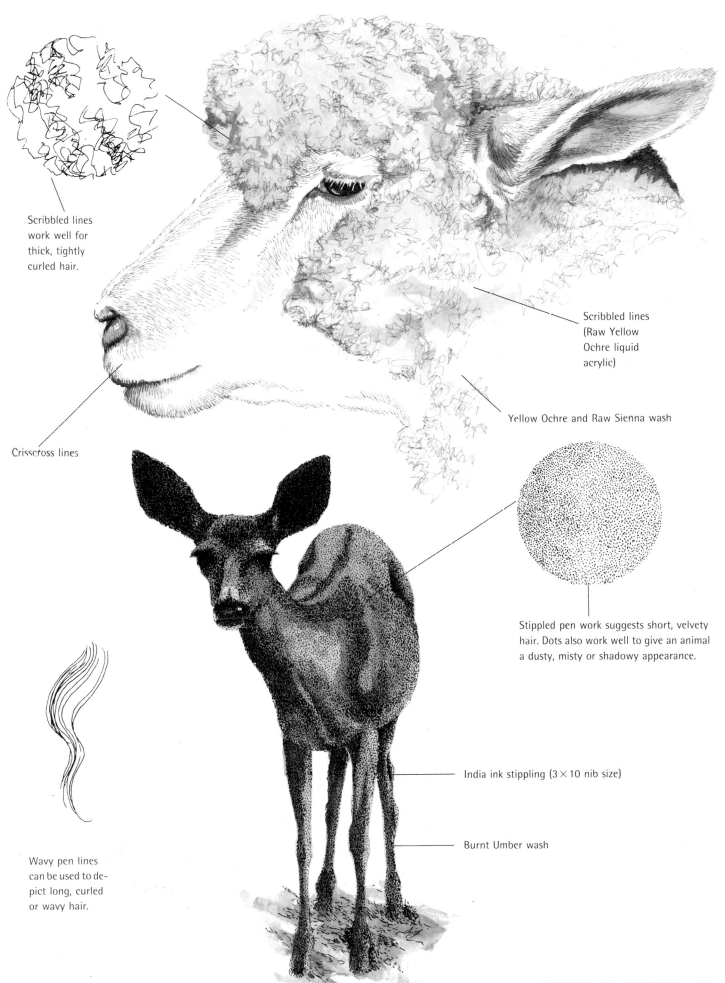

Scribbled lines work well for thick, tightly curled hair.

Scribbled lines (Raw Yellow Ochre liquid acrylic)

Yellow Ochre and Raw Sienna wash

Crisscross lines

Stippled pen work suggests short, velvety hair. Dots also work well to give an animal a dusty, misty or shadowy appearance.

India ink stippling (3 × 10 nib size)

Burnt Umber wash

Wavy pen lines can be used to depict long, curled or wavy hair.

Short Fur in Colored Pencil

CAROLYN ROCHELLE

Carolyn Rochelle's technique involves creating tonal gradations with strokes that follow the direction of an animal's coat, skin and so on, using medium pencil pressure. She usually layers from light to dark, often in a manner that allows underlying hues to show through. Carolyn sometimes burnishes to create reflections and smooth areas but usually limits this technique in favor of layering.

COLOR PALETTE

Berol Prismacolor wax-based pencils:
- Cream
- Burnt Ochre
- Warm Grey 70%
- Burnt Umber

Lyra Polycolor oil-based pencil in Black Medium

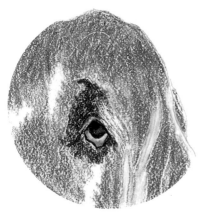

1 Layer Cream, Burnt Ochre and Warm Grey 70%. Use strokes following hair pattern.

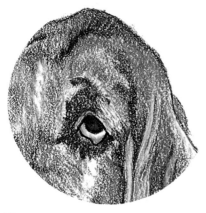

2 Layer Burnt Umber (dark values).

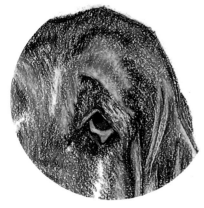

3 Burnish highlight areas with Cream. Layer/burnish details with Black Medium.

Long Fur in Colored Pencil

C A R O L Y N R O C H E L L E

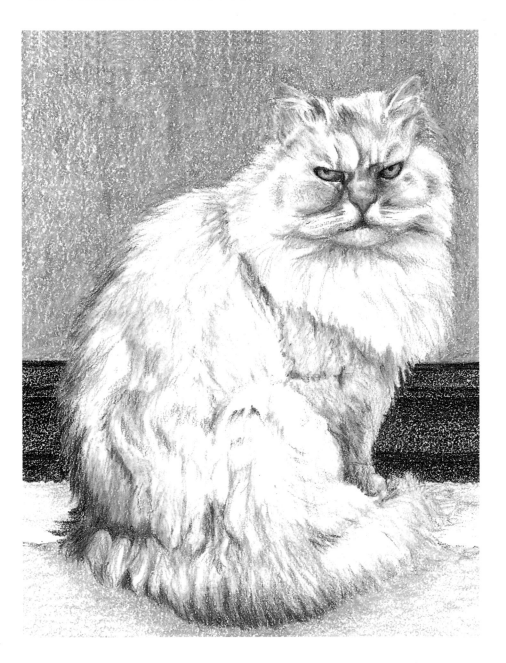

1 Layer entire area with White. Layer Warm Grey 20%. Burnish White.

2 Layer Warm Grey 10%. Burnish White. Layer Warm Grey 30%. Burnish White.

3 Lightly layer Rosy Beige and French Grey 70%.

Shiny Fur in Colored Pencil

CAROLYN ROCHELLE

COLOR PALETTE

Berol Prismacolor wax-based pencils:
- Black Grape
- Burnt Ochre
- Jasmine
- French Grey 10%
- Goldenrod
- Sienna Brown
- Indigo Blue

1 Layer Black Grape and Jasmine.

2 Layer/burnish French Grey 10%. Layer Goldenrod.

3 Layer Sienna Brown, Burnt Ochre and Indigo Blue.

Thick Fur in Colored Pencil

CAROLYN ROCHELLE

1 Layer Cream (light fur). Layer Goldenrod (legs and muzzle).

2 Layer Sienna Brown over Cream as shown. Layer Dark Brown over Dark Umber areas. Burnish with Cream over Sienna Brown/Cream areas. Burnish Dark Umber to redefine the darkest recesses in the fur.

COLOR PALETTE

Berol Prismacolor wax-based pencils:
- Cream
- Goldenrod
- Dark Umber
- Sienna Brown
- Dark Brown

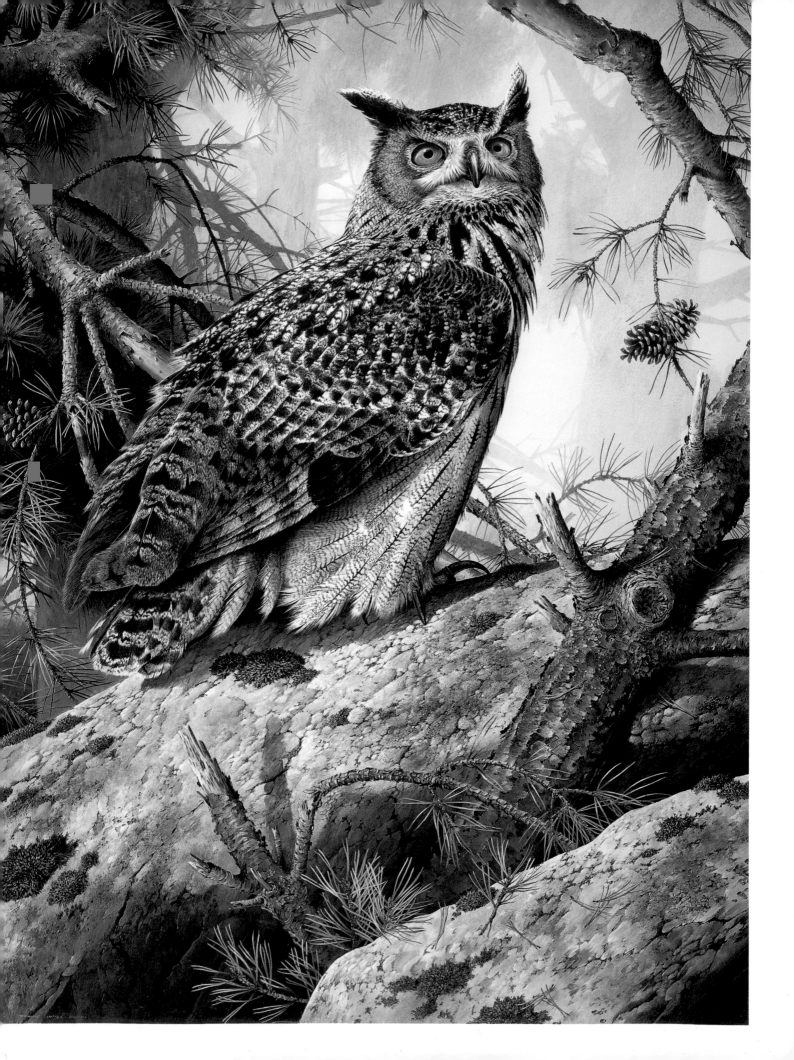

Painting Feather Textures

Feathers are to birds as fur is to mammals. They are the bird's protective covering, and they must serve many functions, including facilitating flight for most species. In climates ranging from the steaming hot tropics to the frigid arctic, feathers enable birds to survive in their environment. Different feather shapes and structures have different functions. For example, most of us are familiar with how effective down feathers are as insulation. Flight feathers, though, are very different from down feathers. All feathers, regardless of function, must develop at each stage of a bird's life to protect it as it grows. But because of the wear and tear they suffer, feathers are replaced annually by a process generally called molting. Many waterfowl species lose all their flight feathers during the molt and are incapable of flying until the new feathers are grown.

Painting feathers can be difficult at times; there are so many shapes, sizes, colors and markings to contend with. It is easy to get so caught up in the pattern of a bird's feathers, like those of a ring-necked pheasant or ruffed grouse, that the final painting of the bird looks like a flat design. It is vital when painting feathered wildlife to maintain the form and to think in terms of light and shadow. Remember that feathers are a covering over the anatomy of the creature.

TERANCE JAMES BOND
"European Eagle Owl"
Acrylic, 40"×30" (102cm×76cm)

Painting Wings and Feathers

Once you understand their basic anatomy, painting wings and feathers becomes a relatively straight-forward process. Using the red-tailed hawk wing as an example, Danny O'Driscoll shows in three steps how to develop a wing.

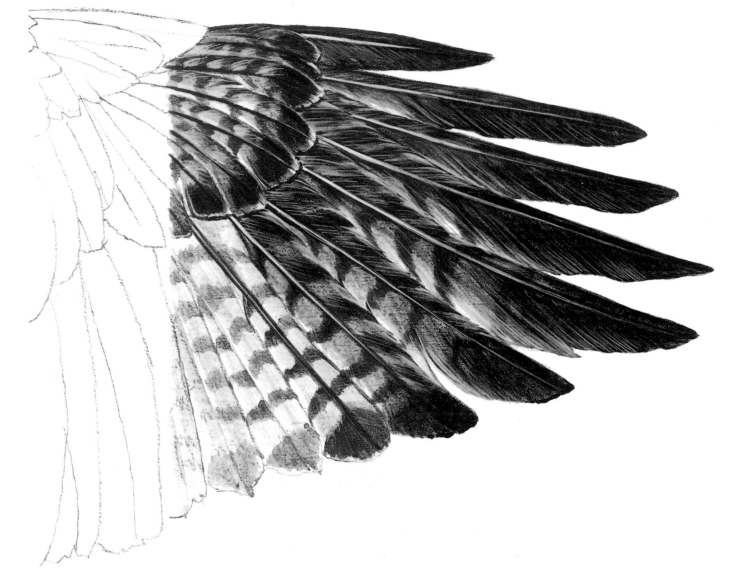

1 Begin with a pencil drawing of the feather tracts, delineating the positions and shapes of each of the primaries and secondaries.

2 Next, render the vanes of each feather and the hawk's characteristic dark bar markings using washes of Mars Black and Ultramarine Blue. Add the darker shape of the rachis and highlight it with Titanium White.

3 Glaze the feathers with a pale wash of Burnt Umber, and glaze the lighter portions of the feathers with Acra Gold. Add highlights where necessary to define separations between fibers in the vanes, and then apply additional glazes of Burnt Umber and Acra Gold where necessary to darken shadows and build subtle variations of color.

Anatomy of a Wing

A close look at an extended wing reveals that feathers are grouped into *tracts* that vary according to the flight requirements of each bird species. The number, size and shape of the feathers in each tract are also distinctive for each species. Flight feathers, or primaries, radiate from a point roughly two-thirds of the way between the wing root and tip. The area remaining between the wing root and primaries is occupied by secondaries, which are generally parallel to each other.

There are six basic wing shapes, adapted for the unique flying styles of different birds:

1. Short, broad and cupped for rapid takeoff and short-distance flight (robins, for example)
2. Short and broad with slotted primaries for soaring flight (hawks)
3. Flat, moderately long, narrow and triangular for high-speed flight (terns)
4. Large, distinctly arched wings for slow, powerful flapping flight (herons)
5. Long, narrow, flat and pointed for gliding flight (petrels)
6. Short, pointed, swept-back wings for hovering (hummingbirds)

Take a look at Danny O'Driscoll's drawings of the anatomy of the extended wing of a red-tailed hawk as seen from above and below. You can locate the hawk's ten primary feathers, twelve secondary feathers and the many feathers comprising its six lesser tracts.

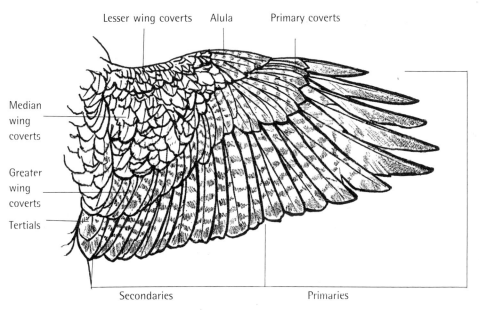

Upper Wing Surface of Red-Tailed Hawk

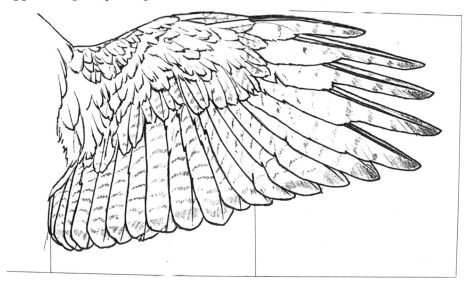

Underside of Red-Tailed Hawk Wing

Anatomy of a Feather

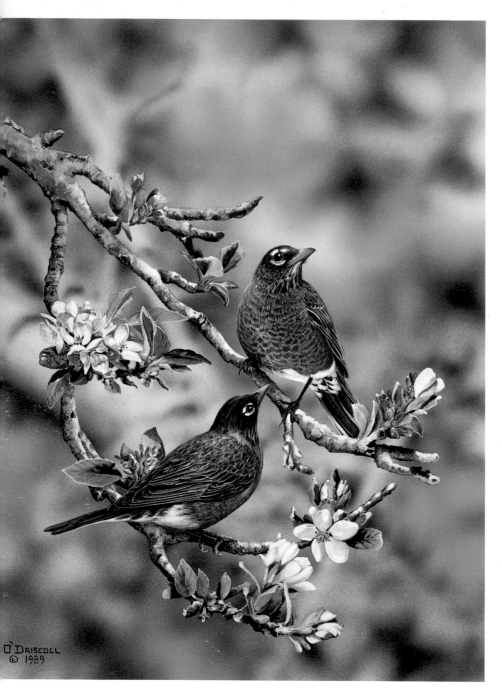

O'DRISCOLL © 1989

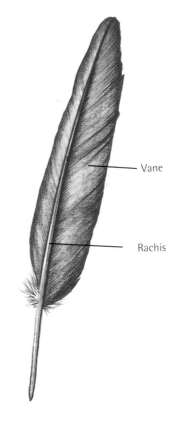

Vane

Rachis

Robin's Feather

This robin's feather illustrates how a song-bird's wing is short, broad and cupped for rapid takeoff and maneuverability among branches and vegetation.

Sketch by Danny O'Driscoll

DANNY O'DRISCOLL
"Robins and Apple Blossoms"
Acrylic, 18" × 14" (46cm × 36cm)

Although the size, shape and function of individual feathers vary greatly according to the species of bird and the feather's specific location on the wing or body, all feathers share a basic structure: a stiffer central shaft called a rachis from which the vane or flight surface of the feather extends left and right. The wing feathers of birds that spend much of their time flying while migrating or searching for food quite often overlap their tail feathers. For example, when a red-tailed hawk is at rest, its wing feathers extend about halfway down the length of its tail. In contrast, the wings of songbirds that fly shorter distances or must maneuver among branches and vegetation are typically shorter and more rounded at the tips.

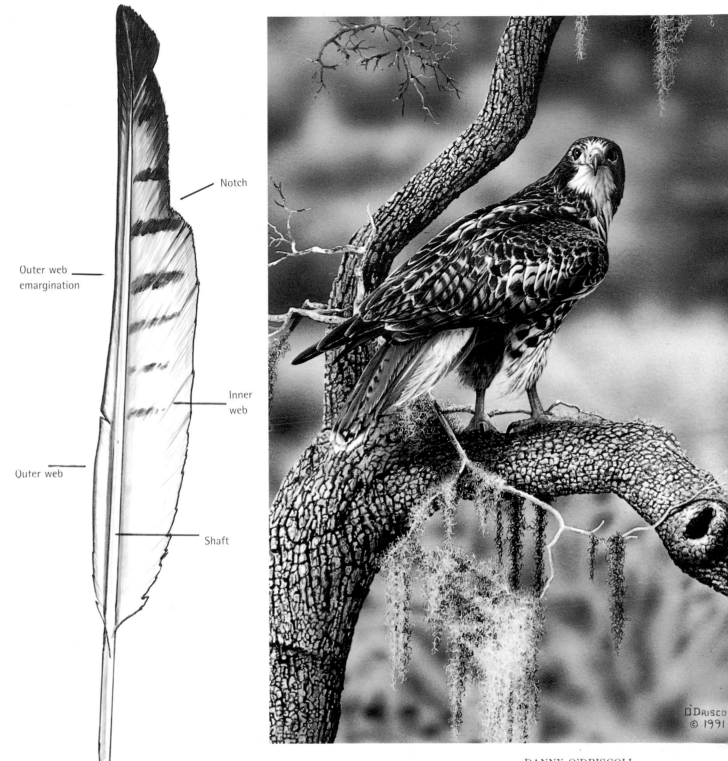

Notch

Outer web
emargination

Inner
web

Outer web

Shaft

DANNY O'DRISCOLL
"Red-Tailed Hawk"
Acrylic, 20"×16" (51cm×41cm)

Red-Tailed Hawk's Primary Flight Feather

Like most large raptors, red-tailed hawks have a conspicuous slot or notch on each of their outer five primary feathers. This feature assures great stability in flight. Buteos, or soaring hawks, have broad, rounded wings and long, broad tails that allow them to soar on thermals (rising currents of warm air) and gives them the incredible maneuverability and speed necessary to pursue prey in a variety of habitats.

Sketch by Danny O'Driscoll

Duck Feathers in Acrylic
Wood Duck

R O D L A W R E N C E

This is the underside view of the left wing of a female wood duck. The illustration is life-size.

1 Start with two base colors. One is a medium value representing the general color of the wing lining next to and including the primary and secondary feathers. The second is a lighter and grayer color, representing the feathers located closer to the leading edge. These have the small brown spots on them. Each of these bases takes about three to four coats of paint to build up. Next, take your transfer sheet and trace the major feathers over the painting. The entire illustration can be completed with three brushes: a sharp-tipped no. 2 round sable; a ¼-inch (6mm) flat sable; and an old, worn no. 3 round sable. The last brush works great for doing the subtle washes. With a slightly darker value, outline the feathers, put in a few shadows and feather breaks and suggest a few of the spots.

2 This step is shown on the lower half of the wing. With a darker value, begin to indicate more feather details and darken the shadows. Paint some of the spots darker and suggest the smaller feathers and spots. Mix a lighter value for each area and use washes to show where the light strikes the feathers.

3 To suggest feather details, wash lighter values of thin paint over the individual feathers, painting in the direction of the feather structure. These light colors build up areas on the feathers that are actually lighter, like the tips on the feathers next to the primaries and the small feathers with the spots. With a dark gray/brown paint value, increase the shadows and paint more feather breaks. This step is shown on the top half of the wing at right.

4 Step four is the bottom half of the wing and is a continuation of step three. Work with increasingly lighter and darker values, using them to emphasize the feather texture. Build each up with a series of washes. As the values get very light and indicate the nearly white feathers, add a touch of Cadmium Yellow Light. When using the lighter values for feather sheen, add Burnt Umber, Cadmium-Barium Red Deep and Cerulean Blue. Use your very darkest value last to accent the shadows, spot markings and feather breaks. This dark paint is a mixture of Burnt Umber, Ultramarine Blue, Cerulean Blue and a just a dab of Cadmium-Barium Red and white.

Folded Falcon Wing in Acrylic
Peregrine Falcon

R O D L A W R E N C E

1 The entire bird is shown here, but for now, concentrate only on the right wing. Peregrines have a blue-gray wing color so use that as your base paint. Transfer the major feather groups from your drawing to the painting. The lower primaries appear darker in the model, so use a darker, grayer value as a base there, and use the same color to outline the feathers above these primaries. This establishes their position so you can see them more easily to work on later. Mix a darker shadow color and begin to paint the shadows on each feather. This work is shown in progress on the lower half of the wing.

2 Continue to paint the shadows and use the same value to suggest the feather markings. These can be applied as washes as they near the upper-left portion of the wing, as this is the closest to the light source. Next, mix a lighter value of the base color with white, Cerulean Blue and a tiny dab of Cadmium-Barium Red Deep and use it to show light reflecting off the feathers. You can also use it to start showing the lighter edges of the primaries, secondaries and coverts (the top portion of the wing has been left unchanged to show the progression).

3 Start this step by mixing the next darkest value change. Add Ultramarine Blue, Cerulean Blue and Burnt Umber to offset the color, so it won't appear too blue. Use this and one more mixture of yet another darker value to work on the feather shadows and markings. Use washes and straight paint, working darker as you move to the feathers on the right, the shadow side. Mix two lighter values and paint in a similar method on the light side. Use these values in light washes, building up the glaze over several applications.

4 The final step is to use your darkest dark and lightest light paint values. To the light paint, add a little more white and a dab of Cadmium Orange to warm it up. Paint this on the feather edges and the feathers reflecting the greatest light. The dark value is Burnt Umber, Ultramarine Blue and a few dabs of white and Cerulean Blue. Paint this in the deepest shadows and feather breaks. This was only applied on the lower half of the wing. You can see the upper-left portion of the wing looks unfinished by comparison. It needs this dark and perhaps a few slightly lighter highlights to finish it. The wing is finished from the greater coverts down.

Paintings With Open Wings

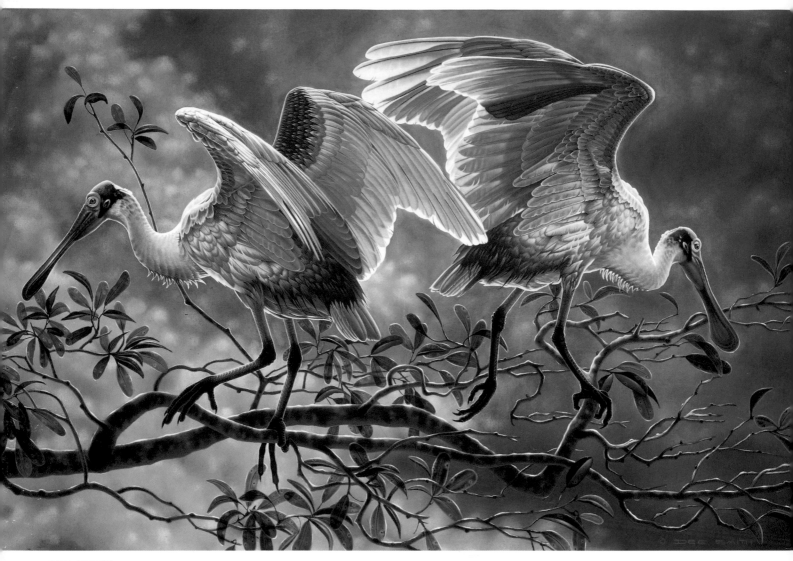

DEE SMITH
"Rose Adagio" (Roseate Spoonbills)
Oil on canvas, 24″×36″ (61cm×91cm)

USE MULTIPLE GLAZES

During the mating season, artist Dee Smith observed two roseate spoonbills with their brilliant wings open, moving gracefully around each other through the mangrove branches as if they were performing a ballet. The brilliant rose colors of their plumage, most vivid during the mating season, captivate the eye immediately, but she wanted to capture this dance as the posturing of the birds created elegant and unusual poses. Consequently, the painting is titled *Rose Adagio*, named after a dance from the classical ballet *Sleeping Beauty*. Of all the birds Smith has painted, she finds the roseate spoonbills the most challenging. From a distance they seem to be just pink, but when seen up close and with creative lighting, the pinks become a myriad of hues. To achieve this pink, Smith mixed Cadmium Red and Zinc White. She mixed her oils thinly and used many glazes, warming the pinks with light yellow and cooling them with blue-grays. To make the detailed birds stand out, she dry-brushed the background to soften it.

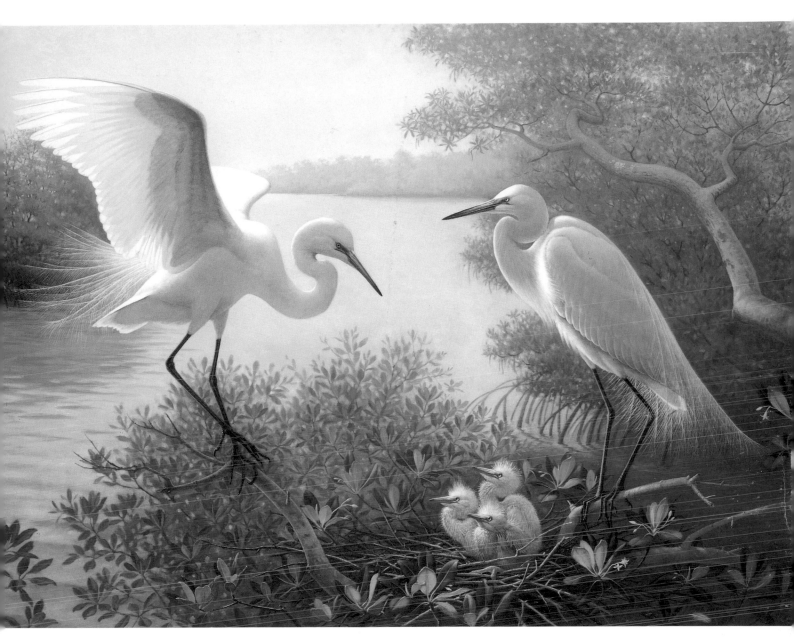

DIANE PIERCE
"Mangrove Miracle" (Great Egret Family)
Oil, 38"×56" (97cm×142cm)

BRING SUNLIGHT TO YOUR PAINTING

After a half century of pursuing, observing and raising birds, and thirty-five years of painting avian species, artist Diane Pierce still places them at the top of her admittedly long list of favorite things. "Life without birds would be very sad," says Pierce. "Their grace and beauty, character, ability to fly, their individual lives, the places they dwell in and around, all fire the imagination."

She loves to paint light effects, though it is frustrating to try to capture sunlight, which, she comments, is a thousand times more intense than the whitest canvas. You must learn to "lie to tell the truth," to employ Impressionist techniques to bring the sun to the canvas." It is difficult to separate my love of birds from my fascination for light. They are one and the same to me."

Songbird Feathers in Acrylic
White-Throated Sparrow

R O D L A W R E N C E

1 Because of the basic gray-and-brown pattern to this bird, break his form into these two color areas. Start with three base colors to build on. One is a tan area for the back and wing feathers. The other two areas are gray, one for the head and then a warmer gray area for the rest of the body. It takes several thin coats of paint to build these areas to an opaque base. When this is done, use your transfer sheet to reestablish the feather patterns that you had worked out on your layout drawing. Pencil in some head details to show that area better.

2 Mix a darker color paint for each area, but not so dark that it appears shocking. The greatest contrast is at the top of the head, because that area will be black against white. Use this step to draw with your paint, using thin washes and building up some areas for a more opaque look. The light is coming from above the bird, so make your shadows on the wing feathers thicker as they curve around and down the body. You can easily make corrections over this, as the contrast is not too bold. Later, you can deepen the areas necessary for darker shadows and add lighter values to accent the suggested forms.

3 Use some slightly darker values in this step, but these are still far from what will be your final dark. Emphasize the form with darker shadows and indicate darker markings on the feathers. Also use some lighter values to begin the indication of light striking the bird's form. At this point you have a somewhat detailed but faded-looking bird.

4 Some dramatic changes take place in this step as a result of the addition of the final dark and light paint values and the brighter colors. Use washes of primarily Burnt Sienna to build up color on the wing, in the shoulder area. The yellow spots take several washes. Try to convince your eye that the wing curves from the top to the side by using color and value. Both are lighter on top and darker on the bottom. Use a thin wash of almost white to make a subtle sheen on the very top of the wing, where the light would reflect off these feathers. A few dark lines suggest feather breaks to complete the look of this beautiful songbird.

Pelican Feathers in Watercolor

MICHAEL P. ROCCO

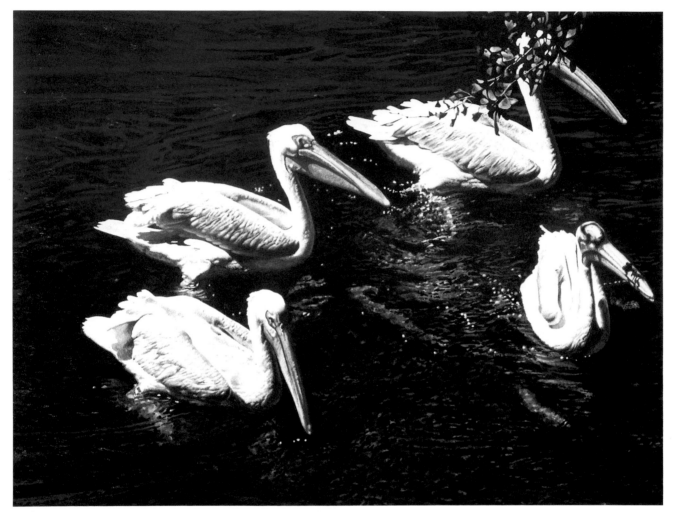

MICHAEL P. ROCCO
"Pelicans"
Watercolor, 17"×23" (43cm×58cm)

Form, texture, dramatic light; those are the things that artist Michael P. Rocco saw through the lens of his camera when he photographed a scene of pelicans at the zoo. "Where else would I find pelicans in Philadelphia?" says Rocco. The brilliance of the birds' down contrasted highly by the deep blue of the water captures the imagination, and Rocco was fortunate to have a group of birds float into the composition, which made it much more interesting but more time-consuming to paint. Though pelicans are not generally thought of as graceful birds, their beauty becomes evident in his painting.

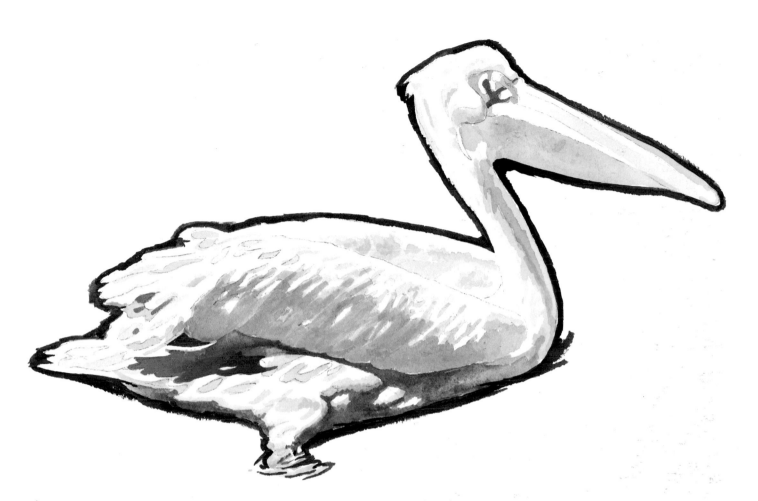

1 Establish the form and bulk of the bird by painting the pale colors of the down's
shadows and those that help shape the graceful neck and left wing. Hold the clean
white of your paper for highlights throughout the painting. Put in the first colors of the
beak, then additional color on the neck. Paint intermediate shadows on the right wing to
further its form. Define this wing with definite shadows on the bottom. As the body nears
the water, paint various colors that are caused by light reflecting off the water. Put in the
muscle shadows on the thigh. At this point, you can outline the bird with the dark back-
ground color to establish its contours and value relationships. For the full-size painting,
bring each bird to this stage, then paint the entire background with a 1-inch (25mm) flat
brush.

2 Develop the body further with deeper shadows, paying attention to the reflected light that is invaluable to form. Add color and texture to the beak, and begin establishing the jowl and the bulbous flesh around the eye.

3 With a no. 2 brush, add color and texture to the down, putting in shadows that help raise sections of feathers and detail their formation. Tone down the reflected light of the right wing and intensify the adjacent shadow, which increases the feeling of form. Give the neck the same treatment. Finish detailing the eye and its surrounding area, and accentuate the shadow on the jowl. Add texture to the beak, and gently shade its bottom for form. Paint the unusual shadow on the beak, and accent the small growths near the neck.

Pen-and-Ink Techniques
Pelican Head

C L A U D I A N I C E

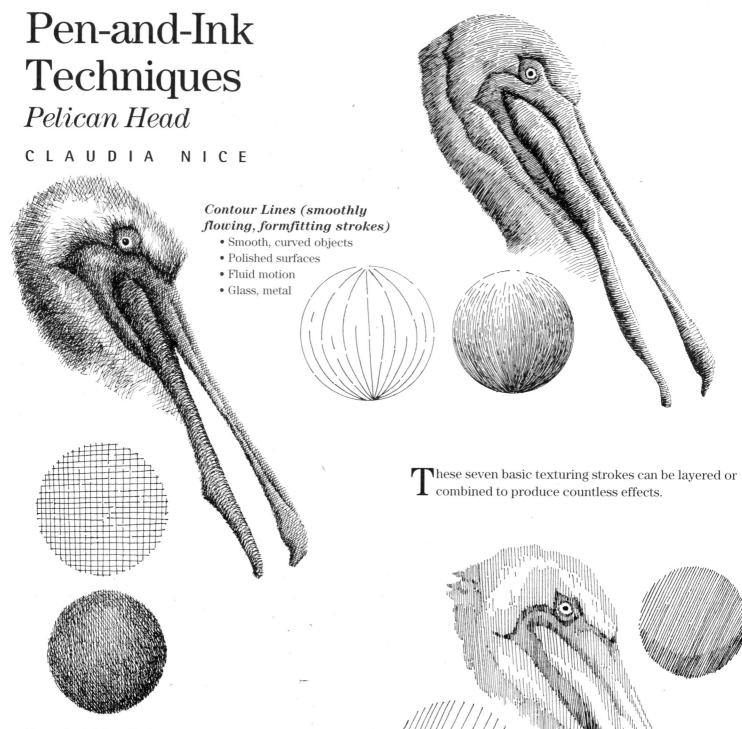

Contour Lines (smoothly flowing, formfitting strokes)
• Smooth, curved objects
• Polished surfaces
• Fluid motion
• Glass, metal

These seven basic texturing strokes can be layered or combined to produce countless effects.

Cross-hatching (two or more intersecting lines)
• Deepen tonal values, heavy shadows
• Roughened texture varying in degrees according to angle, precision and nib size

Parallel Lines (straight, freehand lines, stroked in the same direction)
• Smooth, flat objects
• Faded, hazy, misty or distant look

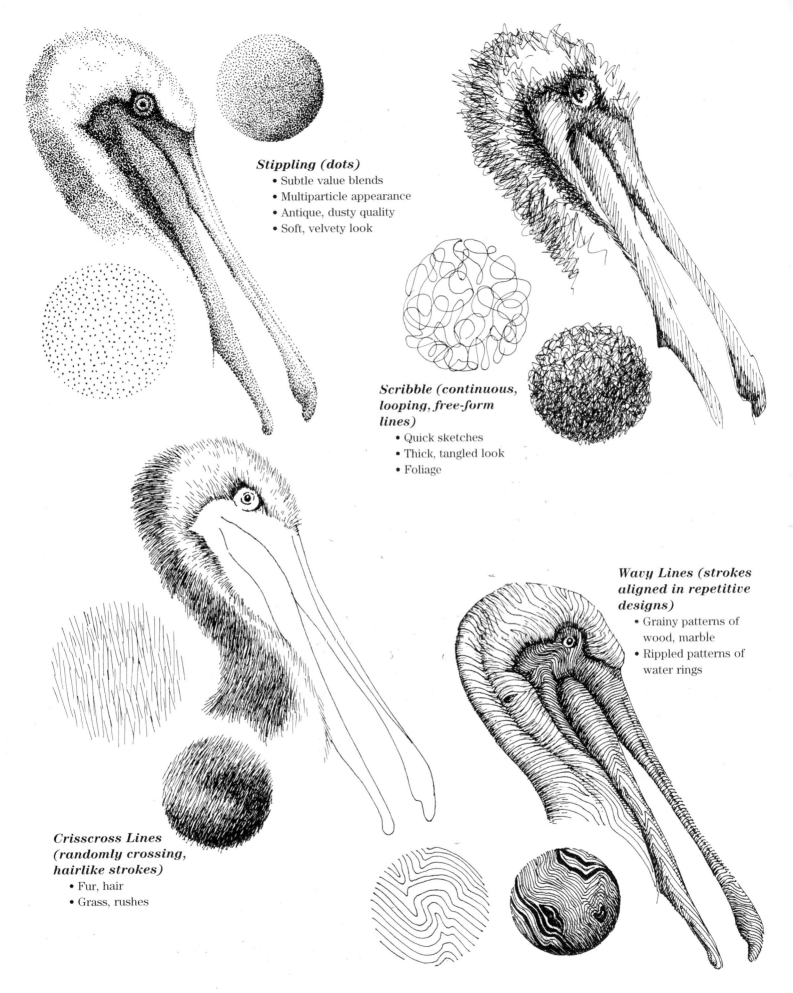

Stippling (dots)
- Subtle value blends
- Multiparticle appearance
- Antique, dusty quality
- Soft, velvety look

Scribble (continuous, looping, free-form lines)
- Quick sketches
- Thick, tangled look
- Foliage

Wavy Lines (strokes aligned in repetitive designs)
- Grainy patterns of wood, marble
- Rippled patterns of water rings

Crisscross Lines (randomly crossing, hairlike strokes)
- Fur, hair
- Grass, rushes

Feathers in Pen and Ink

CLAUDIA NICE

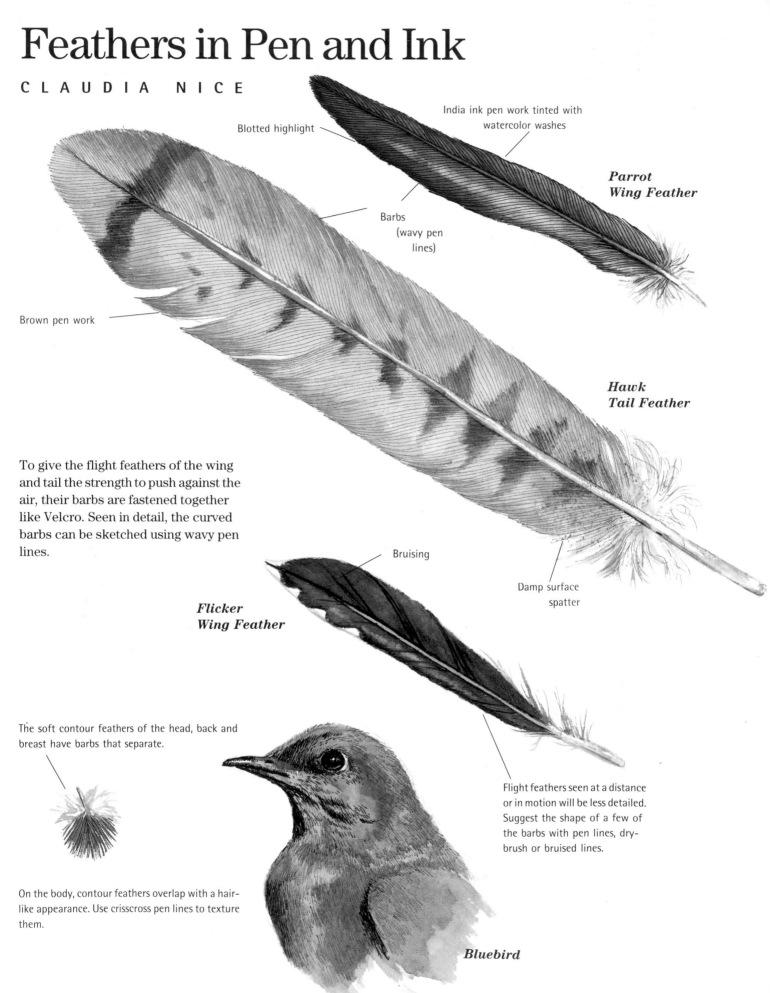

India ink pen work tinted with watercolor washes

Parrot Wing Feather

Blotted highlight

Barbs (wavy pen lines)

Brown pen work

Hawk Tail Feather

To give the flight feathers of the wing and tail the strength to push against the air, their barbs are fastened together like Velcro. Seen in detail, the curved barbs can be sketched using wavy pen lines.

Bruising

Flicker Wing Feather

Damp surface spatter

The soft contour feathers of the head, back and breast have barbs that separate.

Flight feathers seen at a distance or in motion will be less detailed. Suggest the shape of a few of the barbs with pen lines, dry-brush or bruised lines.

On the body, contour feathers overlap with a hair-like appearance. Use crisscross pen lines to texture them.

Bluebird

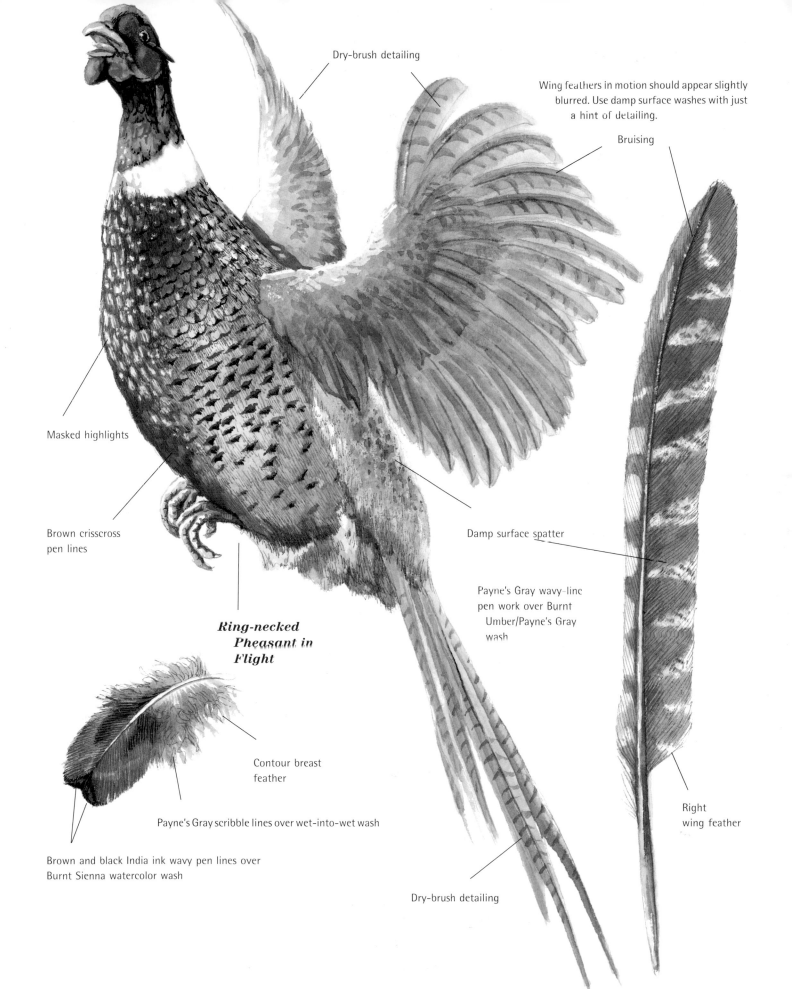

Dry-brush detailing

Wing feathers in motion should appear slightly
blurred. Use damp surface washes with just
a hint of detailing.

Bruising

Masked highlights

Brown crisscross
pen lines

Damp surface spatter

Payne's Gray wavy-line
pen work over Burnt
Umber/Payne's Gray
wash

**_Ring-necked
Pheasant in
Flight_**

Contour breast
feather

Payne's Gray scribble lines over wet-into-wet wash

Right
wing feather

Brown and black India ink wavy pen lines over
Burnt Sienna watercolor wash

Dry-brush detailing

Parrots in Colored Pencil

CAROLYN ROCHELLE

1 Layer Yellow Chartreuse on wing feathers. Layer Green Bice in darker areas. Layer Cream in adjacent chest area. Layer wing edge with Mediterranean Blue.

2 Layer/burnish Olive Green in shadow area and to define individual feathers. Layer Limepeel on small feathers. Layer Canary Yellow on lower chest feathers. Burnish with White, blending blue feathers and highlight areas.

4 Layer head feathers with French Grey 50%. Layer Burnt Ochre and Indigo Blue to define feathers.

3 Layer Raw Umber to define chest feathers. Layer/burnish Indigo Blue to darken shadow areas. Layer red chest area with Poppy Red and burnish with Cream. See main painting.

COLOR PALETTE

Berol Prismacolor wax-based pencils:
- Yellow Chartreuse
- Green Bice
- Cream
- Mediterranean Blue
- Olive Green
- Limepeel
- Canary Yellow
- White
- Raw Umber
- Indigo Blue
- Poppy Red
- French Grey 50%
- Burnt Ochre

Parrots in Oil

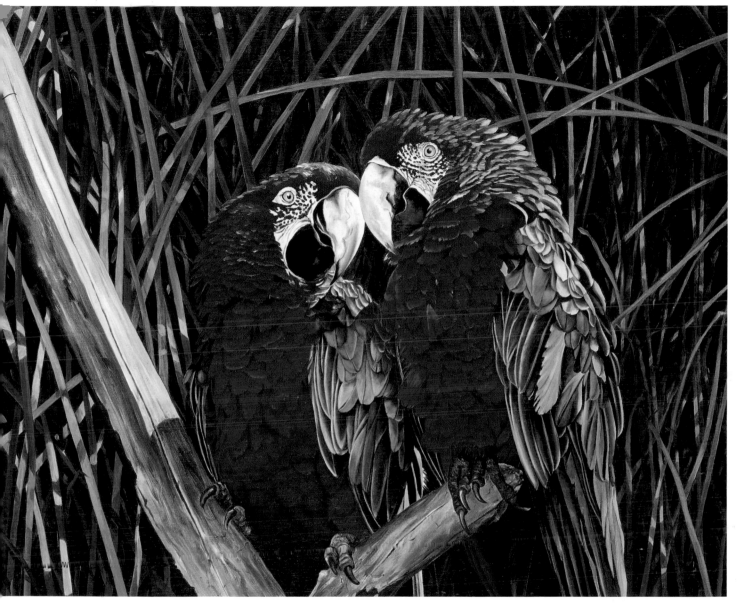

LAURA GILLILAND
"Rollo and Ruby" (Red and Green Macaw)
Oil on canvas, 24"×30" (61cm×76cm)

RELATE SUBJECTS TO ONE ANOTHER

Artist Laura Gilliland has spent countless quiet hours observing her models and photographing their behavior. She feels she must know the moments that precede and follow the one she wishes to capture on canvas so that she may create a three-dimensional story that conveys a beginning, middle and end, but in two dimensions. Gilliland begins by transferring to canvas the images she has chosen to paint from photos she has taken—sometimes combining landscapes, models and other details.

Gilliland first paints her subject's eyes. "As with human beings," says Gilliland, "the eyes are the portals into the soul, and in placing that eye on canvas, my painting takes on soul." To Gilliland, the subject of her painting, in essence, watches over and leads her through its own creation. This technique is what allowed her to offer the viewer the opportunity to glimpse Rollo and Ruby greeting one another with ineffable delight, and to share in this tender, ephemeral moment.

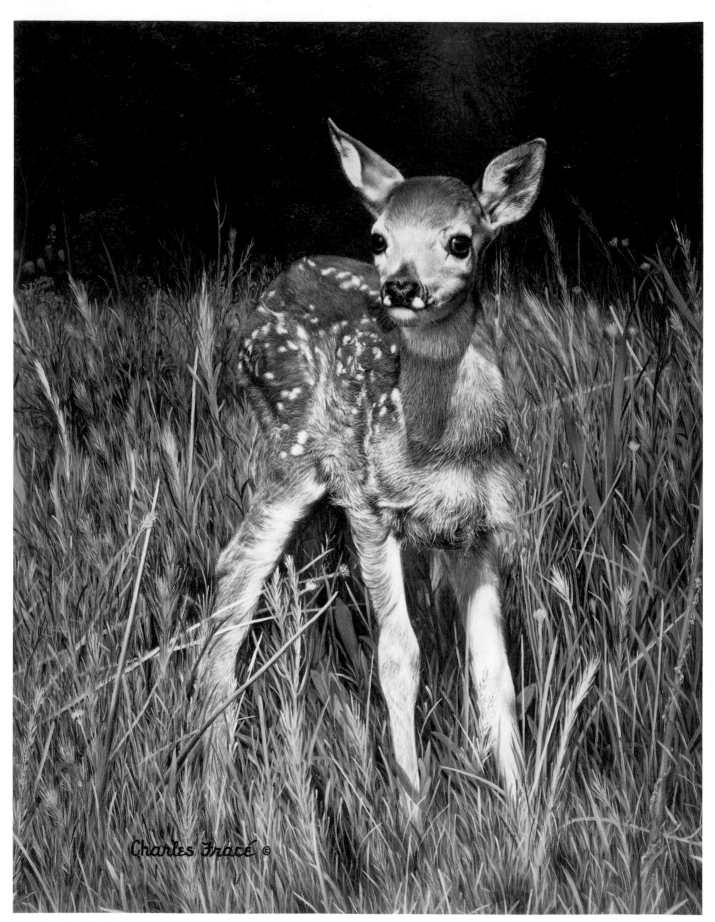

CHARLES FRACÉ, *"New Arrival." Oil, 20"×16" (51cm×41cm)*

Getting Down to Details

Painting credible images of wildlife requires many interrelated skills. These include keen powers of observation, basic photographic skills and the ability to draw and create artistic compositions. The culmination of all these skills is the ability to render the forms and textures of the wildlife subjects you've so carefully observed, sketched, photographed and composed. The wonderful diversity of wildlife species and their varied appearances make it impossible to cover here any great number of these details. Fortunately, certain things are shared by many living creatures: All birds have wings and feathers, all creatures have eyes, and most have tails. "The best way to get the details right is to have an intimate knowledge of the animal and its environment," says Paul Bosman, "then all else follows: getting the anatomy right, recognizing typical gestures, knowing when the animal will do what and why." We hope that the helpful tips presented here will get you on your way.

A Bird's External Anatomy

Knowing the external anatomy of a bird will help you to understand and to become more familiar with the terminology used in bird field guides, books and discussions about birds that may be important to depicting a bird accurately.

Stellar's Jay

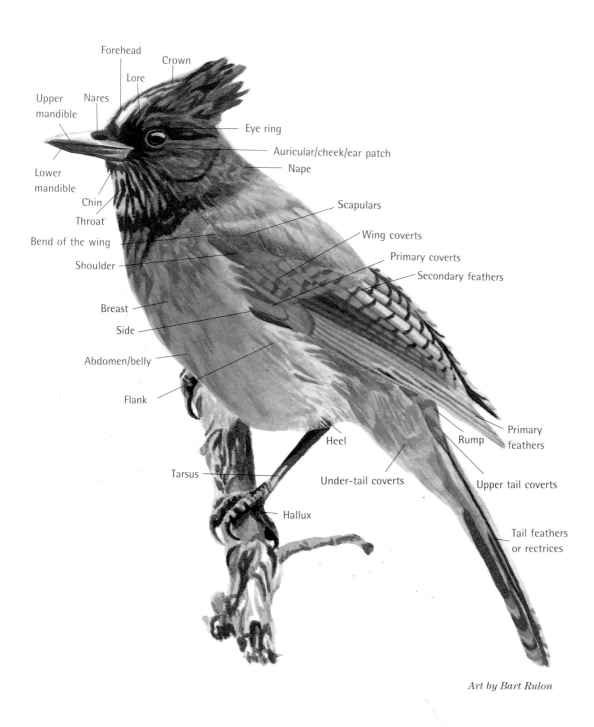

Forehead
Crown
Lore
Upper mandible
Nares
Eye ring
Auricular/cheek/ear patch
Nape
Lower mandible
Chin
Scapulars
Throat
Wing coverts
Bend of the wing
Primary coverts
Shoulder
Secondary feathers
Breast
Side
Abdomen/belly
Flank
Heel
Rump
Primary feathers
Tarsus
Under-tail coverts
Upper tail coverts
Hallux
Tail feathers or rectrices

Art by Bart Rulon

Realistic Feather Spacing

Some feathers, such as the primaries, primary coverts, secondaries, greater wing coverts and tail feathers appear relatively evenly spaced, but the rest of the contour feathers are not nearly as uniform-looking, even if only slightly varied. Be careful to observe each species individually.

Even wing and tail feathers, most evenly spaced when spread, aren't always so uniform, depending on how they are being held. In general, as you move inward on the wing from the primaries and secondaries toward the smaller feathers you are going to see less and less uniformity. Depicting slight variations in feather placement is important to make a bird look convincing.

Right
Attention has been given to the way each feather lies. This results in a more accurate depiction of the feathers and does a much better job of indicating the correct shape of the bird.

Wrong
Feathers are too evenly spaced, looking like fish scales rather than feathers.

Art by Bart Rulon

How Birds Fly

Understanding the basics of flight helps in your ability to depict flying birds correctly. Wings beat forward and down on the downstroke, and backward and up on the upstroke. The inner wing, from the shoulder to the wrist, bearing the secondary and tertiary flight feathers, does not move forward and backward as much as the outer wing does during a flight sequence. The inner wing beats within a tighter margin, providing most of the lift. The outer wing provides most of the forward thrust for the bird in flight.

Starting with the upstroke, the bird lifts its wrists, and the outer wings fold partially, closing the primaries like a fan, thus reducing the resistance as the wing raises. To further battle resistance, the primaries rotate slightly and separate, allowing air to pass through them, then fold as they are lifted up, rotating backward. At the end of the upstroke, the outer wing flips up quickly as the primaries unfold to increase surface area for the down-stroke. For the downstroke, the primaries of the outer wing are pulled down and forward by the wrist. The wing's leading edge is lower than the trailing edge, providing forward thrust.

The more precise details of wing-beat cycles are extremely complex and can vary between species. This is only meant as a simple guide to help you avoid mistakes when depicting birds in flight.

Upstroke

Beginning of upstroke Wing tip swept back

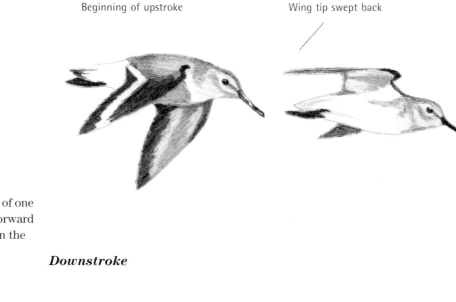

The Wing-beat Cycle
Notice in this approximate sequence of one full wing beat that the wing rotates forward on the downstroke and backward on the upstroke.

Downstroke

Beginning of downstroke

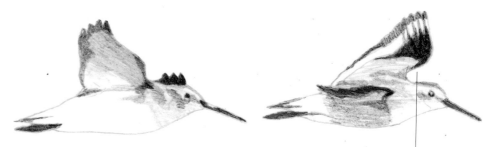

Outer wing comes forward.

Range of Movement

Wrist movement compared to that of the wing tip during a wing beat is different in magnitude. Both move forward on the downstroke and backward on the upstroke, but the wing tip does so with a much greater radius.

Wing tip movement

Downstroke

Wrist movement

Upstroke

Outer wing partially folded

At the top of the upstroke, the primaries snap forward and unfold for more surface area.

End of upstroke

End of downstroke

Primaries come forward.

Art by Bart Rulon

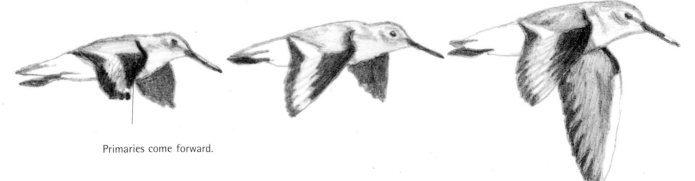

How a Bird Grips a Branch

You might think that birds apply a death grip to everything they land on, but this is not true. Depending on the diameter of the branch or other object, the feet often have a rather relaxed grip. Balance is important to a bird staying on a branch, as well as its grip. Much of the bottom surface area of the toes may not even be touching on a small branch or object. When a bird hangs upside down, the toes will be in contact, but the base of the foot might not even touch the branch.

When a bird lands on a vertical branch, the lower foot and leg, which support most of the weight, will often display a consistent toe arrangement. The two bottom front toes will usually be positioned together, while the other front toe grips farther up. The lowermost leg is always placed at an angle downward from the body to support the weight. In this situation, the other leg (higher on the vertical branch) keeps the bird from falling sideways and will often have a looser grip. The

upper leg will have a more perpendicular angle on the vertical branch than the lower leg does.

STUDY FEET
Get into the habit of looking at bird feet in different situations. Take advantage of being able to see captive birds up close. Do several sketches or take photographs of feet in different positions. The more time you spend studying feet, the more you will understand how they look and function.

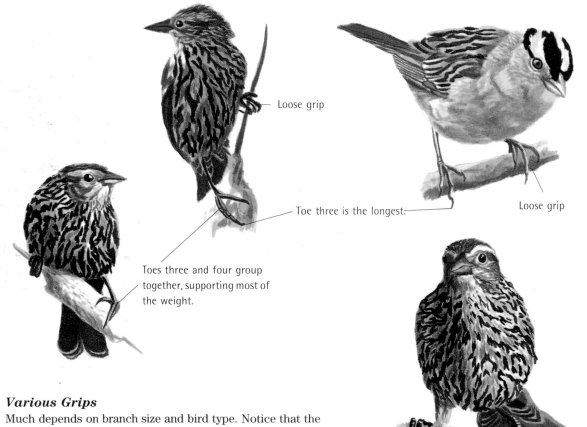

Loose grip

Toe three is the longest.

Toes three and four group together, supporting most of the weight.

Loose grip

Toes grip more tightly due to branch size and tension of alarmed bird.

Various Grips
Much depends on branch size and bird type. Notice that the two birds at left display the third and fourth toe on the lowest foot close together for support. The uppermost toes of the bird at top left are loosely gripped to the top of the cattail, partly because of the size of the stem, and also because the function of that foot in gripping is different from the lower foot. Now compare the grips on the right side. The white-crowned sparrow's grip (upper right) is rather loose, and more on top of the branch, whereas the blackbird's grip looks tighter, probably because of the size of the branch, as well as the fact that the bird is somewhat off balance, alarmed and poised to fly.

Art by Bart Rulon

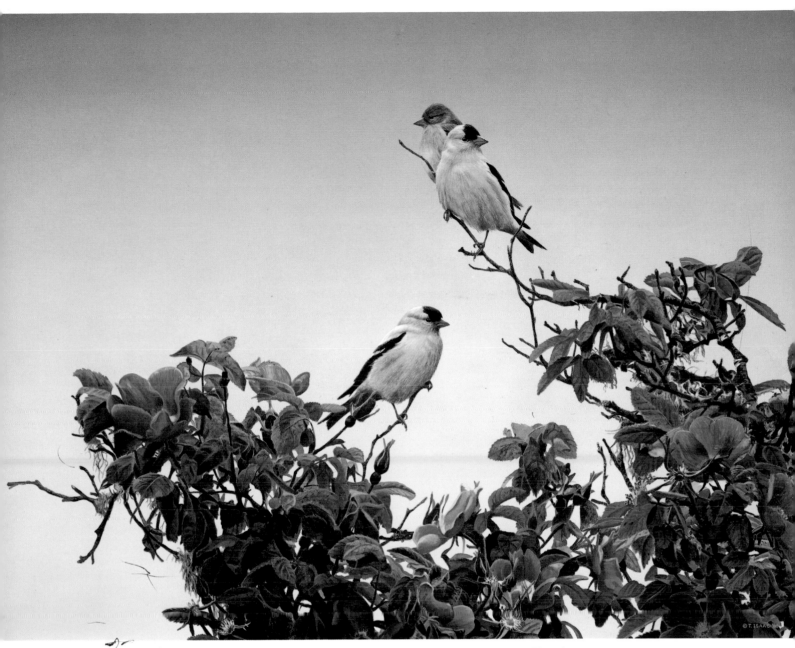

TERRY ISAAC
"Gold on the Rose" (American Goldfinch)
Acrylic, 18" × 24" (46cm × 61cm)
Artwork courtesy of Terry Isaac, © 1988,
and Mill Pond Press, Inc., Venice, Florida
34292

Toe Arrangement

Notice the toes of the lowest foot on the two male goldfinches depicted in this painting. Two of the front toes, toe three and toe four, are bunched together for supporting the weight when these birds are on a diagonal branch. The second toe is separated from the others. Also notice how apparently loosely the toes in this painting are gripping their respective branches.

Depicting Eyes Correctly

There is no foolproof rule for painting eyes. The quality and direction of the light source, the surrounding colors and the actual color of the eyes all affect how the eye looks.

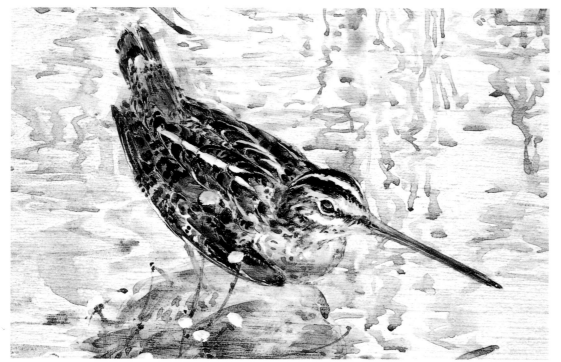

THOMAS QUINN
"Detail of Snipe"
Gouache and acrylic,
25″×38″ (64cm×97cm)

Consider the Surroundings

A detailed view of Thomas Quinn's snipe shows how part of the eye reflects the sky and the other part reflects the surroundings underfoot.

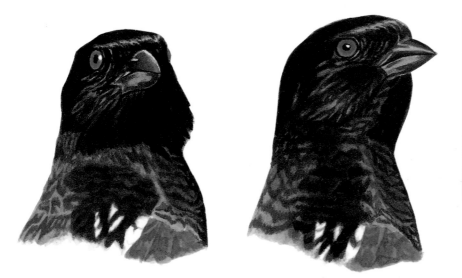

Sketch by Bart Rulon

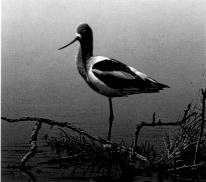

TERRY ISAAC
"Backwater Ballet" (Avocet)
Acrylic, 8¾″×13½″ (22cm×34cm)
Artwork courtesy of Terry Isaac, © 1987

Highlights

An eye facing the sun will have a bright highlight. Compare the eyes pictured here. They are painted representing the exact same lighting situation, with the only difference being that the heads are turned differently. Notice how the bright highlight in the eye is located in a different spot in each case because the bird's head is turned in relationship to the sun.

No Highlight Needed

An eye shaded from the sun will not have a bright highlight. Notice that Terry Isaac did not paint a white highlight in the eye of the avocet above because it is facing away from the light source.

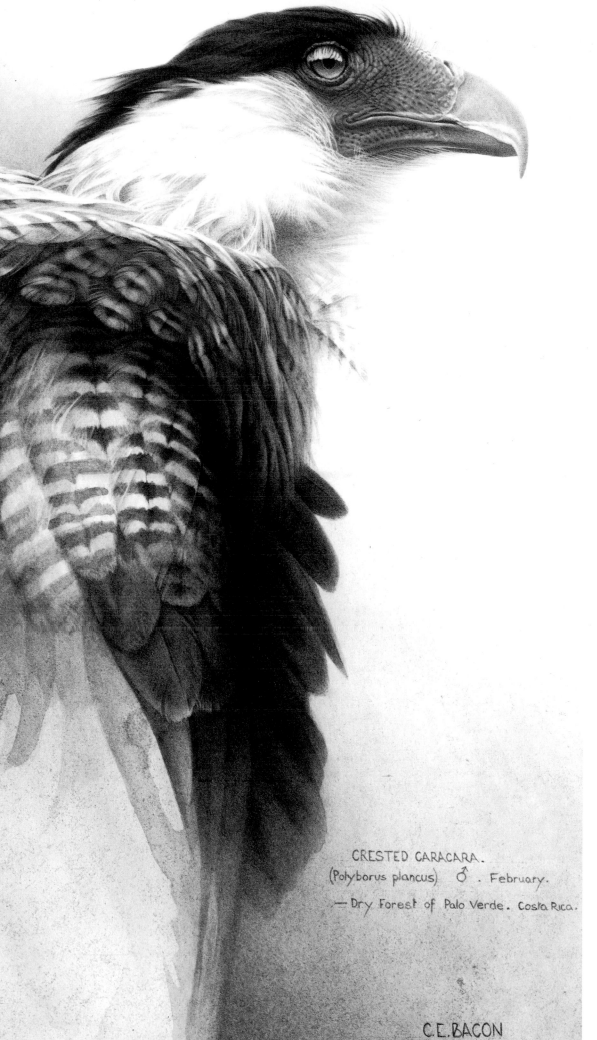

CRESTED CARACARA.
(Polyborus plancus) ♂ . February.
— Dry Forest of Palo Verde . Costa Rica.

C.E.BACON

CHRIS BACON
"Crested Caracara Study"
Watercolor on rag board
10"×6¼" (25cm×16cm)

Eye Reflection

Notice how broad the reflection is and how the eye reflects its surroundings. The upper part reflects the sky on an overcast day, with the light source diffused by clouds. A small, bright, white highlight does not happen in all situations and should never be added unless you can actually see it.

Painting Tails: Fur
ROD LAWRENCE

RED FOX—WATERCOLOR

1 For the fox tail, first wet the paper in the area of the tail, leaving the white tip dry. Then use a wash of three color values, the lightest and warmest on top, the darker, cooler one under the tail for shadow. Before it's totally dry use a sharp-tipped brush, like a no. 1 or no. 2 round, to suggest some hair areas.

2 Some washes of Burnt Sienna accent the tail and indicate deeper areas of fur. Adding Burnt Umber and Ultramarine Gray, continue to do the same to the underside of the tail. For the white tip, use a blue-lavender color made from Burnt Umber, Ultramarine Blue, Cadmium-Barium Red Deep and Cerulean Blue. Darken this to show the shadows and some individual hairs.

3 Add some single hairs to the leading edges and deepen the dark areas to make more pronounced shadows. These are the final fur details.

RED SQUIRREL—ACRYLIC

1 This approach is the same as the fox tail on the preceding page, except the color changes are a bit more dramatic on the squirrel. Keep the values toward the middle range to start with and add shadows according to the light source.

2 Here some thin washes are used for subtle shading and then darker washes are used for rendering areas of detail and shadow. Whenever possible, build on sections of the painting that suggest interesting forms, which were created by the washes in the previous step.

Shadow shapes help give a feeling of mass to the tail and show the form of the squirrel's body.

3 Use a no. 1 round brush to paint the light wispy hairs on the edge of the tail (helping to break up the hard-edged look). Accent both the very dark and very light areas. Several coats may be needed to get a broad solid area quite dark.

Painting Tails: Feathers

ROD LAWRENCE

**MALLARD DUCK—
WATERCOLOR**

1 Use medium light washes to lay in broad color areas. Leave plenty of white areas for lights and iridescent spots. Wet the paper first, but only in controlled areas where you want the paint to flow.

2 Darken the shadow areas and begin to paint some details. Wash in some color for the iridescence, a mix of Permanent Green Light, Ultramarine Blue and Burnt Umber. Blend the edges while the paint is wet. Apply some dark washes over some of this to blend in and create forms.

3 With some washes and dry-brush work, add final details. Adjust dark values to set off the rounded forms of the mallard's tail by accenting the texture and shadows. This will enhance the feeling of light falling on the tail areas.

BLUE JAY—ACRYLIC

1 While keeping the white and light areas of the jay in mind, wash in light values of blue with subtle shading and color variations. Use grays to shadow and form the underside of the tail and body. Keep the gray wash light and slightly warm (using some Yellow Ochre Light in the mix).

2 Use a deep gray-brown wash of Burnt Umber, Ultramarine Blue, Cerulean Blue, white and a little Cadmium-Barium Red Deep and wash in shadows and the dark tail markings. Start with thin washes and build them up.

3 Continue using washes of the darker value to strengthen the deep shadows and to detail feather breaks and pattern edges.

4 With a no. 1 round sable brush, refine the details and sharpen the contrast between light and dark. Add those extra individual strokes to emphasize the feather texture.

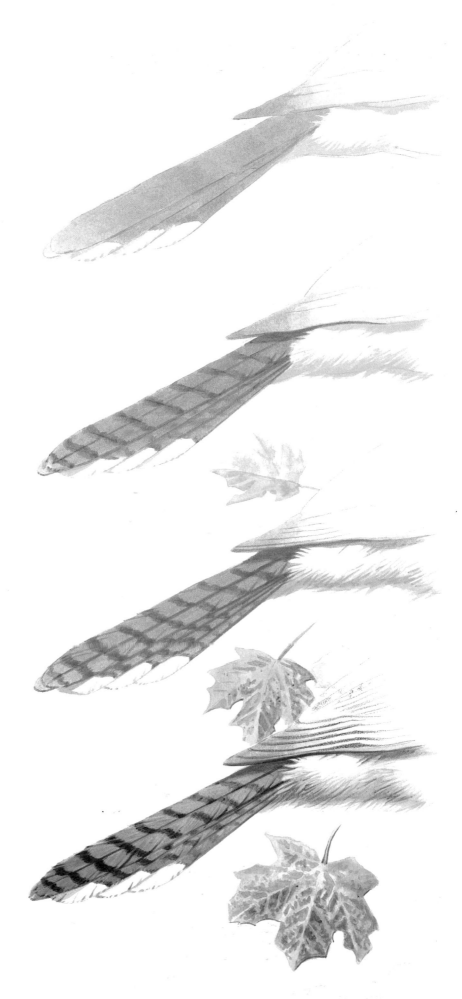

Paintings With "Tails" to Tell

GLAZE WATERCOLOR OVER LAYERS OF GOUACHE FOR BUSHY TAIL

Artist John P. Mullane's goal is to portray a realistic moment in nature. He did this by piecing together many photographs and sketches like a giant puzzle. Mullane tries to make things as detailed and real as possible, but not photographic. "I like to combine gouache and watercolor: Gouache is great for fur and feathers, and watercolor is great for glazing." For fur texture, like on the bushy tail, Mullane usually starts with gouache, building up layers from dark to light and then glazing with watercolor and occasionally with an airbrush. Mullane sometimes will use acrylic mat medium to fix the gouache so he can overpaint without reactivating the underlying paint. He never uses tiny little brushes, but prefers nos. 8, 10 and 12. "With a larger brush," says Mullane, "you can hold more paint, and by rolling the brush you can get a nice sharp tip to create very fine lines."

JOHN P. MULLANE
"Pelham Bay Gray" (Gray Squirrel)
Gouache and watercolor, 9¾" × 14"
(25cm × 36cm)

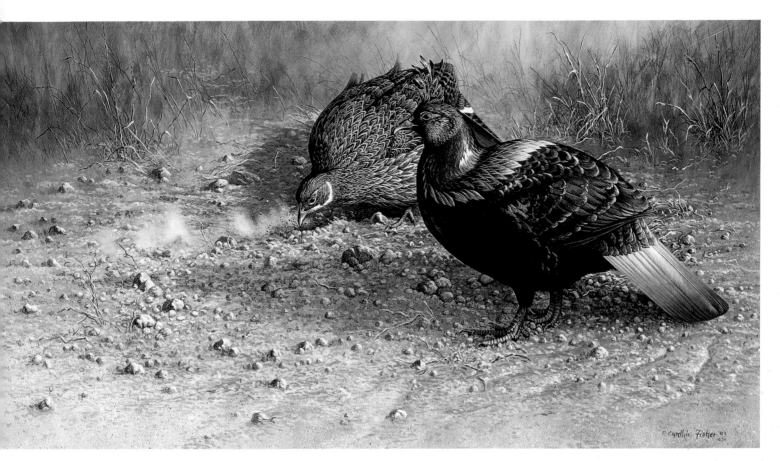

CYNTHIE FISHER
"Himalayan Royalty" (Impeyan Pheasants)
Acrylic, 15" × 30" (38cm × 78cm)

MAKE TAIL COLORS "POP" WITH A THIN LAYER OVER WHITE

Artist Cynthie Fisher works in acrylic on Masonite, quickly covering the gessoed board with a wash indicating the colors and values she wants to depict. Because of the brilliant colors in this piece, she tried to keep the layers to a minimum, maintaining the initial impact of the straight pigments. Fisher established the overall color values on the birds, and then accented the really brilliant areas by painting a layer of pure white paint, letting it dry, and brushing a thin layer of bright unaltered pigment, such as Alizarin Crimson or Cadmium Yellow, over the white area. This allows the full impact of the color to come through, which is hard to attain when white is mixed with the color. This technique works well with iridescence on feathers, or in any area that needs to pop out. "I had ready access to several captive birds," says Fisher, "and I had just finished doing a taxidermy mount of a male Impeyan, so I had lots of references. I sketched from a videotape of pheasants in the wild to get to know their native habits and environment (they live at 15,000 feet above sea level in the Himalayas). I believe these birds are the most beautiful of all the pheasant species."

Sketches by Cynthie Fisher

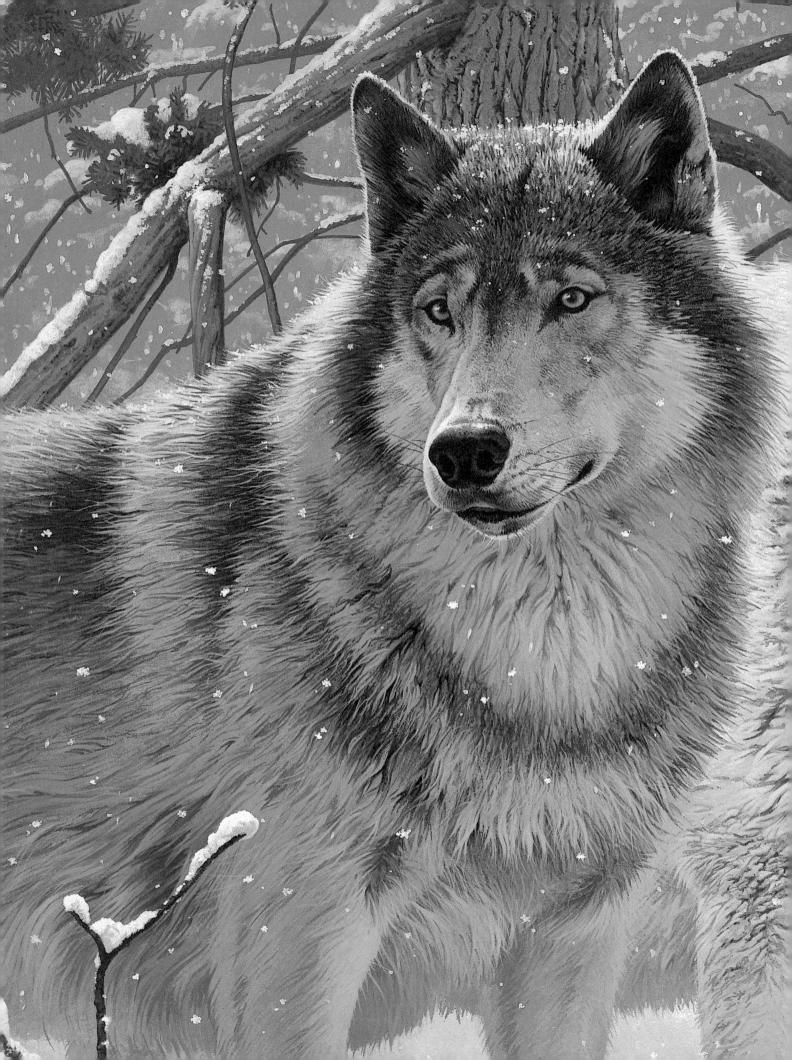

Painting Demonstrations in Acrylic, Watercolor, Oil and Pastel

In previous chapters you've seen how to draw wildlife and you've also learned a number of essential techniques for creating authentic textures and details. Taken together, these techniques allow you to convey authentic scenes of wildlife and its habitat within a framework built on sound artistic principles.

In this section, you'll have the rare opportunity to take an in-depth "look over the shoulders" of five top wildlife artists—a chance to see step-by-step how they bring together the techniques you've seen thus far. But perhaps the most important lesson you'll learn from this section is that regardless of the medium they work in, these artists think and build their paintings using the same basic building blocks available to you—good reference, a solid concept, a well-thought-out artistic composition and sound painting techniques.

ROD LAWRENCE
Detail from "Breath of Winter" (Gray Wolf)
Acrylic, 18"×27" (46cm×69cm)
Collection of Don and Lynda Lewis

Painting a Wolf in Acrylic

ROD LAWRENCE

1 THE BACKGROUND

The background of this painting is completed first, with you knowing you may make some changes on it later, after you have finished the wolf. To start on the wolf, you want an opaque-looking paint base in the color that will be predominant throughout the wolf's body. Mix this base color, keeping it to a middle value relative to the range of values you use. Use paint about the consistency of runny toothpaste and, with a ⅜-inch (10mm) sable bright, build up several layers. While this is not a totally solid color, it is very close and the paint strokes showing through may help in suggesting fur texture. This step reestablishes the wolf's position over the background work. Paint the edges of the wolf's outline and use a fine-tipped no. 3 round sable to show individual hairs. It helps to begin making a ragged, furry edge to the outline of the wolf right from this start, even though it is only a tan silhouette at this point.

2 DRAW IN MAJOR FEATURES ▶

Using your transfer sheet from the original full-size layout drawing, transfer the major features of the wolf to your painting. These include the facial features and some major fur areas, such as the location of the fur cape on the neck and the fur around the face. Mix a color that is the next darker value, a brown/gray color, and use this thin paint to draw over the base color to indicate the shadows, major fur clumps and dark areas such as the eyes and nose. This is an underpainting of sorts; some of it will show through later washes and some of it will be painted over. It helps you plan how and where you are going to paint the fur texture. It also serves as a guide for applying paint as you progress.

3 ADD TEXTURES

Here is a closer view of the wolf, using several different colors, each still close in value when compared to the middle value of the tan base. Slowly build on the textures and details. Some of this paint is applied as a wash and some as a single brushstroke of thicker paint. After some of the other colors are applied, start using an even darker value of paint around the muzzle area. Notice that in comparing the value of this color to the dark values in the background, you are still several steps away from a very dark paint. It is important to keep in mind where the short and long hair is located on the wolf. As you paint the fur, your brushstrokes and details have to be consistent with the length of hair in the area you are working. Keep checking your reference and think *fur* as you work.

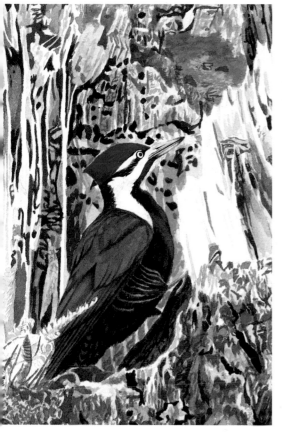

6 USING DARK MIXTURES

Use Alizarin Crimson for the darkest areas and Cadmium Red for feather details on the crown and whisker. To achieve the shadow effects on birds with red feathers, use thicker mixtures of the same reds that make up the lighter areas, rather than adding blue, black or gray to darken them, because the latter mixtures will muddy the colors inaccurately. Apply several washes of French Ultramarine, Alizarin Crimson, Payne's Gray and Burnt Sienna to the back, wings and underparts using a no. 12 round watercolor brush. Then apply a wash of Burnt Umber to the underparts to show the warm color that would reflect from the bark underneath the woodpecker. The upper mandible of the beak is mostly washed with a cool mixture of Payne's Gray, Winsor Blue and Alizarin Crimson using a no. 4 brush. The lower mandible has a warmer color to it, achieved with light washes of Raw Sienna dulled slightly with French Ultramarine.

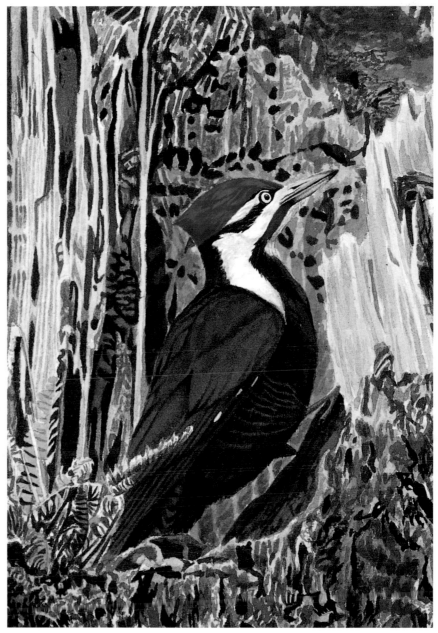

7 THE BLACK AREAS

Slightly darken just a bit more the black areas on the woodpecker. Add feather indications to the white areas. Lastly, add the white markings on the wings with opaque acrylic paint and a no. 2 round brush.

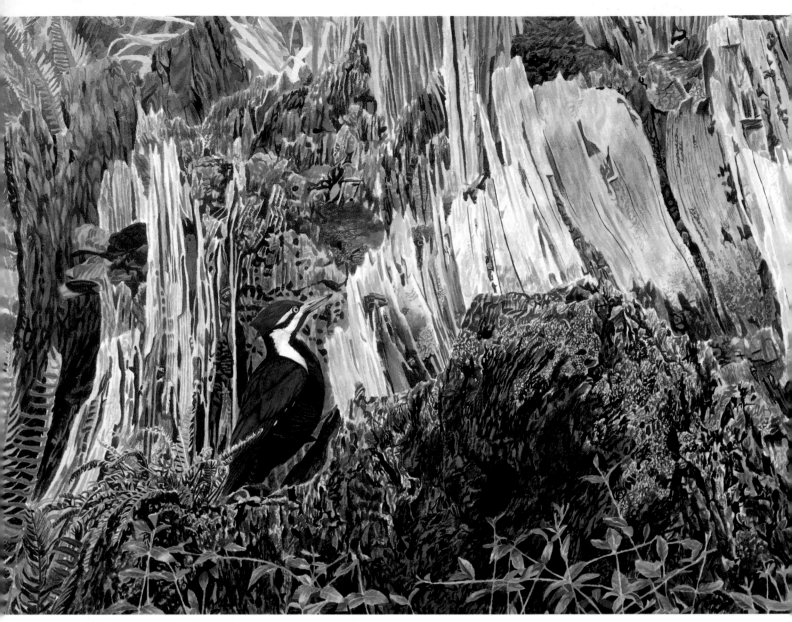

8 REFINE AND FINISH

Bring colors up to their full intensity, and refine edges by adding very intense mixtures in dark areas such as bark crevices. Loosely depict the background vegetation by using a no. 12 round watercolor brush. When nearing the end of a painting like this, focus your attention for a period only on the painting (ignoring the actual scene) to decide if some elements would look more convincing exaggerated in one way or another from the way they actually look in real life. In this painting, Rulon exaggerated the contrast a little more from one layer of bark to the next in order to give a better impression of the space between them (to keep the multilayered stump from looking flat).

BART RULON
"Pileated Woodpecker and Old Stump"
Watercolor, 22"×30" (56cm×76cm)

Painting Canada Geese in Oil

DAVE SELLERS

Dave Sellers's idea for this painting came soon after acquiring a pair of cackling Canada geese for his live waterfowl collection. "To me . . . good art is little more and nothing less than a good, original idea," says Sellers, "but to get the idea across in a pleasing way requires attention to accuracy." He says "the most difficult areas of a bird to capture are the eyes and feet. I try to work out these areas in the drawing stage."

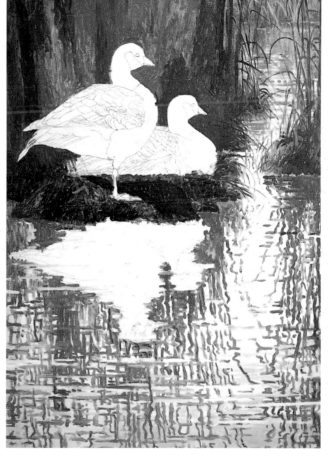

1 BACKGROUND
Begin by applying two light coats of a Raw Umber and Titanium White mixture as a warm underpainting. Avoid too much detail in the background, and use color blocks of Burnt Umber and Cerulean Blue with white and a little Naples Yellow and/or Cobalt Violet. Execute your large areas with a no. 10 ox-hair flat brush.

2 HIGHLIGHTS AND SHADOWS
At this stage, use Naples Yellow and Cobalt Violet mixed in greatly varying proportions to achieve highlight colors as well as shadows. Add Cerulean Blue to achieve cooler shadowy colors and Cadmium Orange and Cadmium Yellow with white to get the warm highlights. Next, develop the water reflections. Try to make them look as much an appealing array of pattern and color as a representation of reflected grasses.

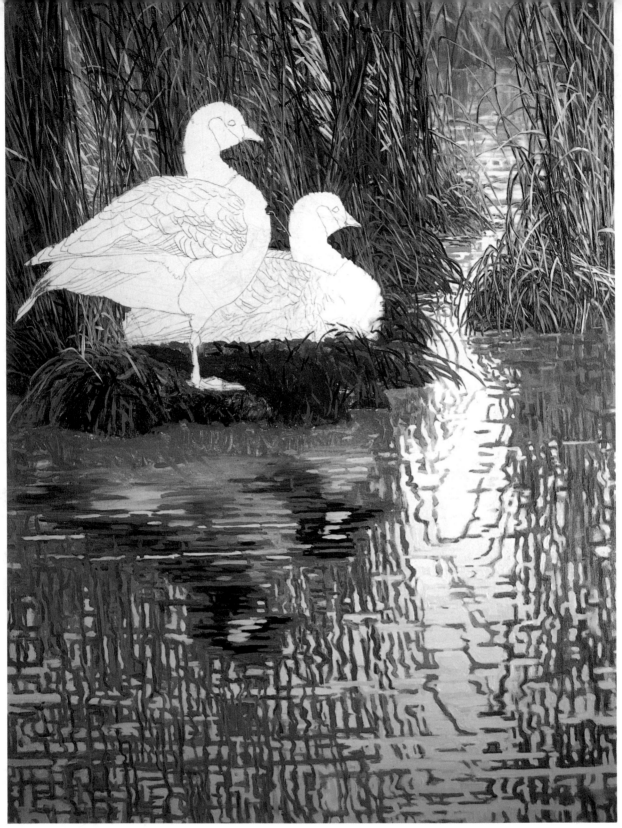

3 GRASSES AND REFLECTIONS

To get the reflections of the geese to blend well with the pattern of the reflected grasses, paint them with the same brushstroke, painting wet-into-wet and weaving them into the mosaic. Paint dark grasses in front of the highlighted ones to develop depth. Use a no. 8 filbert brush to paint the grasses and reflections, and a no. 6 round brush for the more detailed work and some areas on the geese.

SELLERS'S OIL PALETTE

- Titanium White
- Raw Umber
- Burnt Umber
- Burnt Sienna
- Ultramarine Blue
- Cerulean Blue
- Naples Yellow
- Cadmium Yellow
- Cadmium Orange
- Cobalt Violet
- Poppyseed oil (as a medium)

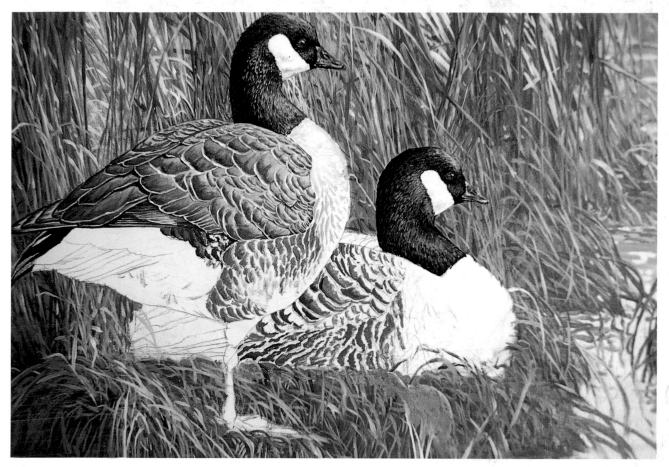

4 BLOCKING IN VALUES

For most areas of the geese, use a no. 4 round synthetic sable brush. Though you generally want to work from dark to light on the subject, block in the bright white on the cheek patches first, then blend shadow colors (those of the water and grasses reflected back on white) wet-into-wet. Use a no. 8 filbert brush to paint the necks, tails and white cheek patches.

For the necks, start out with a black coverage, then work in feather values wet-into-wet. Add in the brightest highlights, however, when the paint is dry, so as not to dull them too much. Use the same dark-to-light technique on the bills.

EYES

For the eyes, first paint in the color of the iris and the dark pupil and let this dry. For a reflection of the surroundings, split the eye in half, top to bottom, with the middle reflecting the horizon line. For the top half of the reflection, mirror the sky, with the top right corners having a bright highlight reflecting from the sun and the top left side having a duller blue reflection from the blue sky. Paint the iris color brightest on the bottom half of the eye because this is where the sun shines through the eye, catching the iris and making its color shine the brightest.

For sides, flanks and breasts, start out by painting a dark to medium value representing the middle of each feather with a mixture of Cerulean Blue, Burnt Umber, Cobalt Violet and white.

5 DETAILING THE FEATHERS

Many beginning painters will often assume that a feather's brightest highlights will be at the tips. Most feathers, however, are quite rounded and somewhat shiny, which causes light to be reflected mostly at the base. So with that in mind, and while the breasts, sides and flanks are still wet, paint the feather edges with a light mixture of Naples Yellow, Cobalt Violet and white. Then blend them wet-into-wet into the midtone of the feather. The nice thing about using Naples Yellow in this situation is that it doesn't turn greenish when mixed. Next to the highlight of the feather edges, paint a blue mixture of Cerulean Blue, Burnt Sienna and white. Most of the feathers here will go from the blue to the core feather color to the highlighted feather edge. Execute your brushstrokes in the same direction that the feather barbs grow.

MIXING BLACKS

Sellers mixes Burnt Umber and Ultramarine Blue together for his blacks.

SKILLFULLY CONTROLLING CONTRAST

Sellers develops more contrast in the geese than in the surrounding grasses. He says, "This helps to bring the birds out, but it is important to know how subtle the difference should be. If it is overdone, the entire piece can look contrived."

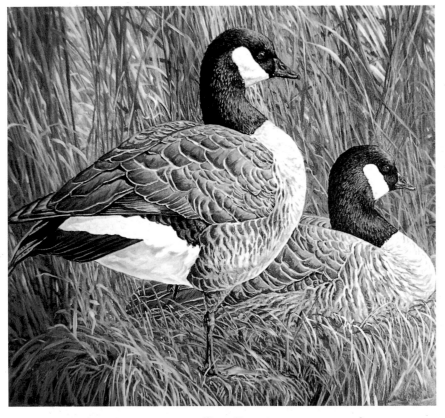

Detail

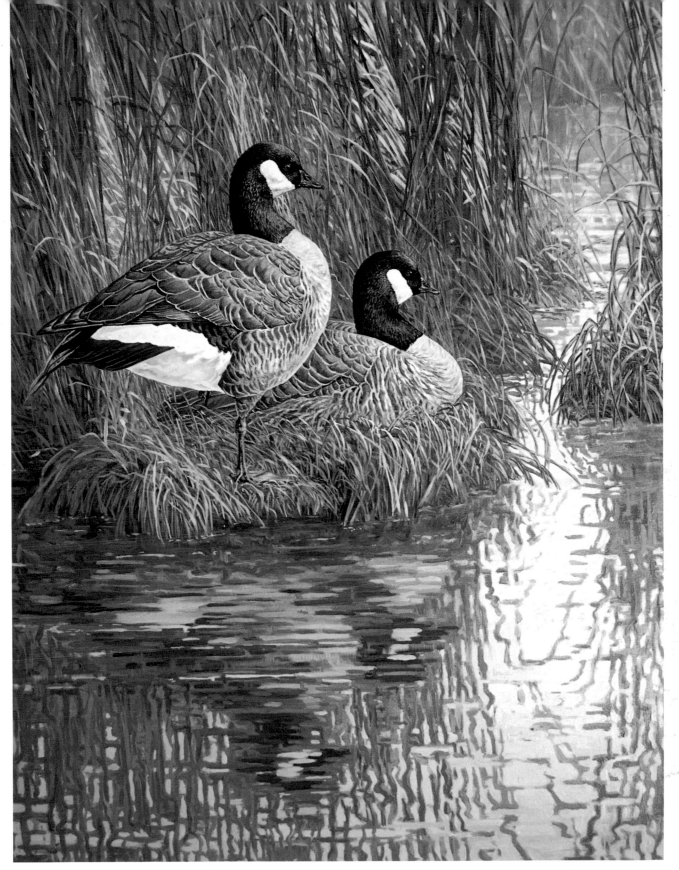

6 **FINISHED PAINTING**
To finish, simply build and clean up the reflections.

DAVE SELLERS
"Cackling Canada Geese"
Oil, 36″×23½″ (91cm×60cm)
Collection of Pete and Diane Lawrence

Painting a Raccoon in Pastel

PAUL BOSMAN

"One of the most common mistakes beginning wildlife artists make," says Paul Bosman, "is not having an animal looking as though it belongs in the picture. Very often, not enough thought has gone into placing the animal naturally and linking its tonal values and colors to the surrounding habitat. It's also important to get the animal's perspective correct so it won't be alienated from its background."

Bosman accomplishes these goals in several ways. First, he becomes intimately familiar with his subject via personal observation and sketching. Second, he keeps an extensive library of 35mm slides. "I take my own reference photographs," he says, "because when I view a slide, I'm immediately taken back to the moment when I took the shot. I remember the time of day, the time of year, the circumstances relating to the particular incident and its outcome—everything from the smell of the dust to the sound of a stampede."

It is this kind of firsthand knowledge that provides Bosman with an understanding of animal gestures and helps give his paintings a feeling of substance and authenticity. When it comes time to paint, he makes certain that disparate elements from various reference materials work together as a cohesive image by settling on a consistent light source and using a well-coordinated palette to ensure unity of color and lighting throughout the image.

For *Oak Creek Bandit*, Bosman wanted to depict a raccoon's creekside hideout based on observations and sketches he'd made during frequent hikes in Oak Creek Canyon not far from his home in Arizona. Feeling that the flood-strewn brush and round pink and gray river stones along the water's edge would make an interesting study of colors and textures, he pulled out all the slides and sketches he had on file of creeks, riverbanks, trees, brush, stones, water and raccoons.

Original art—actual sketch used for Oak Creek Bandit.

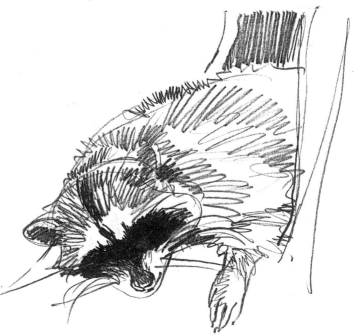

1 THUMBNAIL SKETCHES

"After drawing a few quick thumbnail sketches," says Bosman, "I decided that a sketch of a raccoon placed in the upper third segment on a diagonal line had potential, as long as I left enough space between the lair and the water to include some of those attractive stones."

2 COMPOSITION SKETCH

Using a piece of layout paper about half the size of the final image, carefully draw the composition with a 2B pencil, positioning the elements in an interesting arrangement and getting an idea of the overall dynamics and tonal values.

"I wanted to place some brush debris along the riverbank in the upper-left corner to lead the viewer's eyes to the raccoon's face," says Bosman. "Then, they'd move down to the turbulence in the water, which is where the raccoon's attention would also be focused. Overall, the movement in the painting would be in a Z shape with the viewer's eyes returning to the focal point—the raccoon's face."

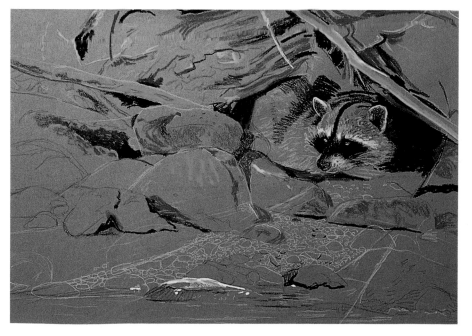

3 BLOCK IN

Draw each of the elements onto a sheet of cork-colored Canson pastel paper. "I chose this color," says Bosman, "to provide an overall warm tone in keeping with the red rocks of the Sedona area." Using pink and black CarbOrthello pastel pencils, lightly draw each of the elements. "My intention was to keep the top third of the painting in shadow and the lower two thirds in sunlight, with the light coming from about ten o'clock." With this in mind, begin drawing the raccoon using black and a small amount of white to establish its tonal range, and stick pastels to introduce additional colors.

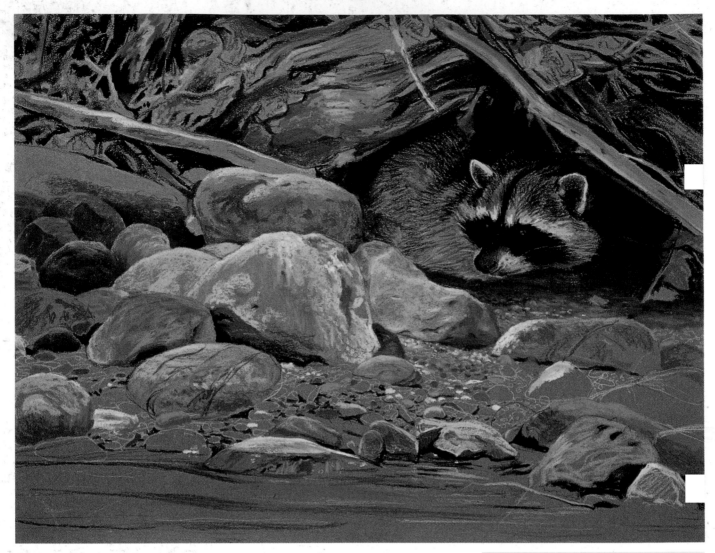

4 MORE COLOR

Continue developing the entire image (except for the water) using a palette of Rembrandt stick pastels. To draw attention to the raccoon, use more black on it than anywhere else and blur the edges of elements in the background. Position the larger blue-gray stones in the foreground so that they break into the Z composition for interest while the smaller reddish-tan stones subtly reinforce the Z movement. Except for using a little finger smudging here and there, apply your colors in fairly strong pastel strokes, and sharpen details in the raccoon with pastel pencils.

BOSMAN'S PASTEL COLORS

- Permanent Red Deep
- Mars Violet
- Light Oxide Red
- Burnt Sienna
- Caput Mortuum Red
- Indian Red
- Burnt Umber
- Red Violet Deep
- Grey
- Bluish Grey
- Mouse Grey
- Ultramarine Deep
- Black
- White

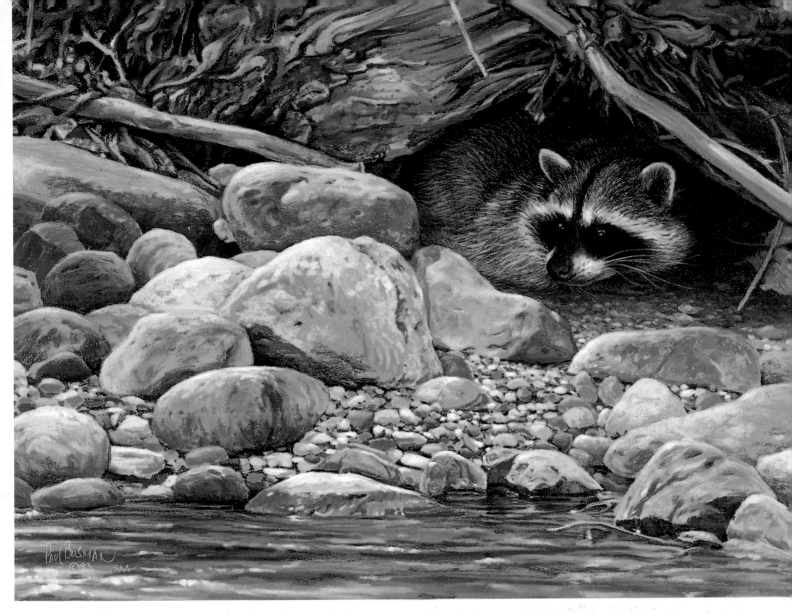

PAUL BOSMAN
"Oak Creek Bandit"
Pastel on Canson paper, 19½" × 25½"
(50cm × 65cm)

Original sketch used as basis for Oak Creek Bandit

5 FINISHING DETAIL

As you work toward completion, allow the paper color to show through as much as possible to unify your colors. Intersperse the warm-toned rocks with grays as well as with both warm and cool colors on individual rocks. By juxtaposing warm and cool colors, you achieve a pleasing effect in both elements of the composition and in strokes of color that are in close proximity. Finally, indicate the foreground water and blur it slightly to direct the viewer's attention toward the more sharply focused raccoon.

Once you have essentially completed the painting, put it away for several weeks. When you look at it again, your eyes will be fresh, and you may decide to rework certain elements. "When I looked at it again," says Bosman, "I decided it needed softening generally and that the small stones needed brightening. I added a few drips of water on the larger stones because I wanted viewers to think about the role of predator and prey. What was the raccoon watching that had caused the slight turbulence in the water? Were those wet foot marks on the rocks? Had he tried a few moments before and failed?"

Painting a Duckling in Oil

JAY J. JOHNSON

Artist Jay J. Johnson's inspiration for this painting came from a combination of two experiences. One spring, he spent a morning watching ducklings at a local nature center, and a few weeks later saw more ducklings during a kayak trip on the Concord River.

PAINTING SURFACE

Jay J. Johnson paints exclusively on Masonite hardboard for his oil paintings. He says, "Other brands of hardboard may be flaky and come apart. I like the smoothness and the firmness of Masonite. It's more rugged and durable than canvas, and it packs easily for shipping."

He prepares his panels with three to four layers of gesso (including back and edges to prevent warping) applied with a very soft 1½-inch (38mm) brush, sanding between layers. In addition, Johnson says, "Around the borders I put a piece of ⅛-inch (3mm) removable typewriter correction tape. I leave this on until I'm finished with the entire painting process, then peel it away so that I have a perfectly straight-edged white border. . . . When the painting is framed, very little of the image is covered up. . . . It also helps in preventing damage . . . since accidents (chipping, fingerprints, etc.) happen mostly on the edges."

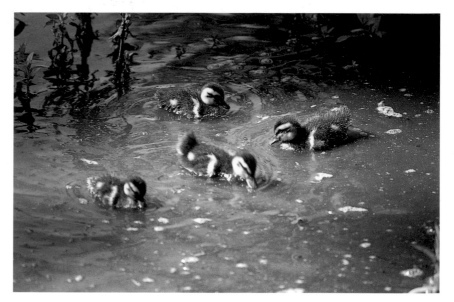

Pencil Sketch
First do a sketch to work out size, composition and balance.

JOHNSON'S OIL PALETTE

- Cadmium Lemon
- Winsor Yellow
- Cadmium Yellow Medium
- Cadmium Yellow Deep (orange)
- Cadmium Red
- Bright Red
- Cadmium Red Deep
- Mauve Red Shade
- Cobalt Blue
- Ultramarine Blue
- Permanent Green Deep
- Oxide of Chromium (green)
- Chrome Green Deep
- Naples Yellow
- Yellow Ochre
- Raw Sienna
- Burnt Sienna
- Burnt Umber
- Raw Umber
- Lamp Black
- Ivory Black
- Titanium White

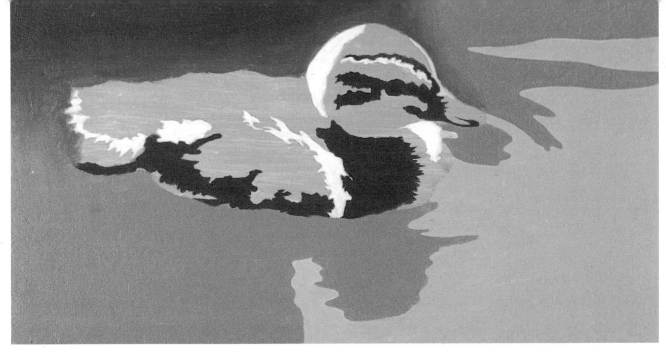

1 BLOCKS OF FLAT COLOR
Start painting by applying blocks of flat color, keeping in mind how the areas in the water compare with each other. "By adding a little blue to the brown areas and vice versa," Johnson says, "I arrived at shades that worked well together.... The duckling blends in nicely, and as an undercoat I've started with a shade similar to the brown water." Save the colors you mix in 35mm film containers so that you will have plenty to use throughout your work on the painting.

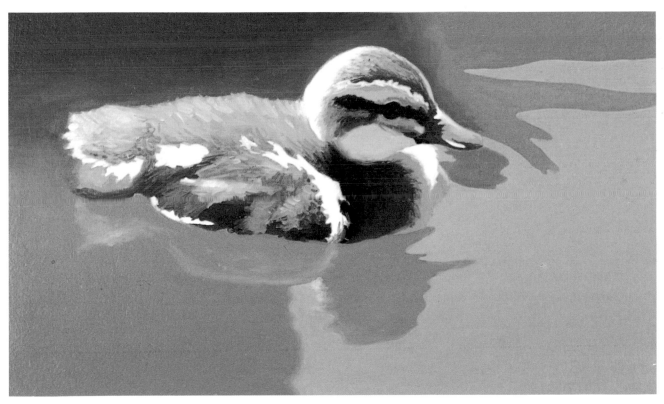

2 FOUNDATION FOR REALISTIC WORK
Apply thin layers, aiming toward a three-dimensional effect. Soften edges and add some details, adjusting your initial colors slightly.

For the bright to dark transition on the duckling's breast, first lay in the two extremes, and also an intermediate value to help in the transition that will be blended later. Further paint the bird's bill with blocks of color.

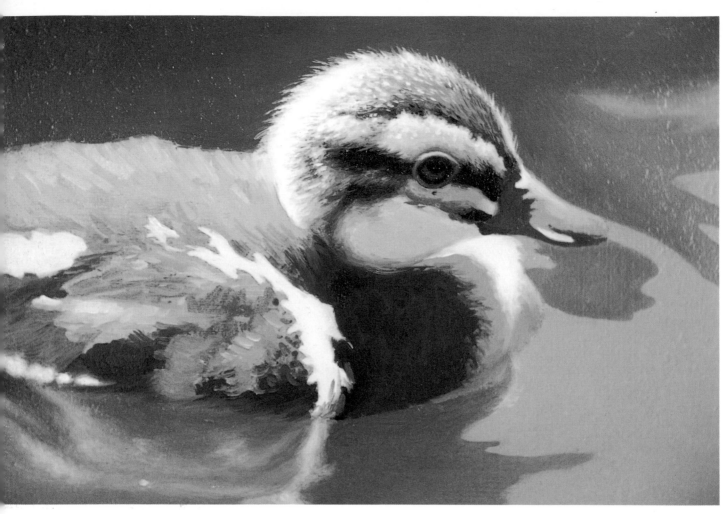

Palette in Progress

Use four shades of one color for the duck-
ling, and apply each with a separate brush.
Remember that colors look darker against
a white palette than they do in a painting.
Compare, for instance, the cheek color on
the duckling and on Johnson's palette.
"Colors appear differently depending on
what surrounds them or is adjacent to
them," says Johnson. "For example, gray
seen on white appears dark, while the same
gray on black appears light."

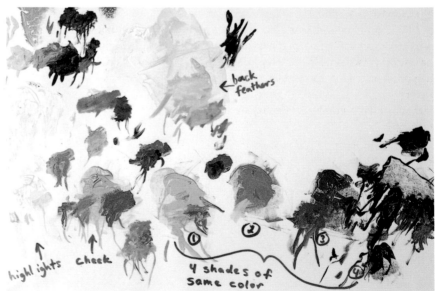

← back
feathers

↑ ↑
highlights cheek

4 shades of
same color

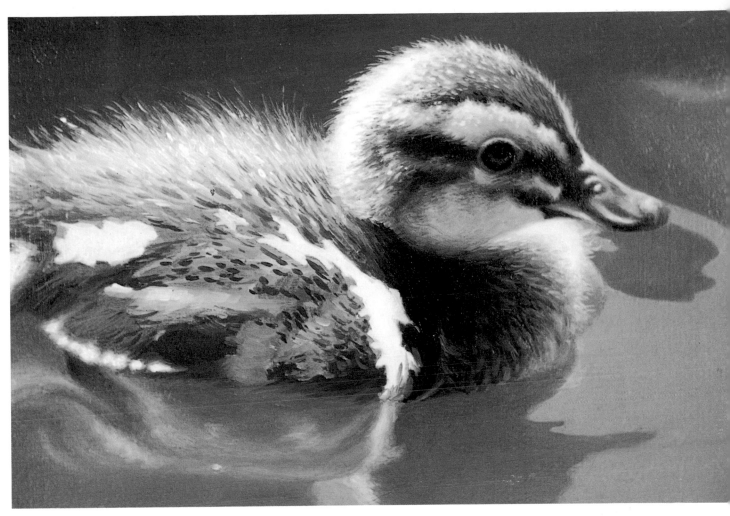

3 DOWNY FEATHERS

For feather details, start by wetting each area of the painting with a thin layer of paint (previous page). Then blend darker and lighter colors wet-into-wet from your palette. "In particular it was helpful to have the water behind the duckling's back wet first before painting in the downy back feathers," says Johnson, "since this allowed for a realistic blending of the hair-fine strokes with the water."

Blend the transition between the bright and dark areas of the duckling's breast wet-into-wet using one brush each for the lightest and darkest colors. Apply a middle tone, then work the dark into the bottom and the lighter mixture on the top. Keep in mind the direction and subtle shapes of the downy feathers as you work. Use refined linseed oil as a medium for maximum blending time. Finish the bill by using the same wet-on-wet technique.

Jay J. Johnson likes using the wet-into-wet technique for painting downy feathers since they are so soft. He tries for more of an overall feeling of fuzziness with downy feathers, rather than trying to paint individual feathers like those on an adult bird. "I'm striving for three things at this stage," says Johnson, "a strong sense of light, the softness of the feathers and true colors."

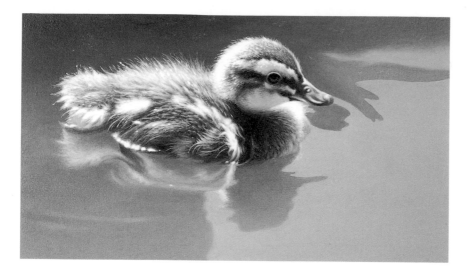

4 SOFT TOUCHES
Continue to work on the feather textures on the front area of the wing and soften feathers wherever needed with touches of paint here and there. Begin to soften reflections in the water. Note how the water at this stage has a cool blue-green tone.

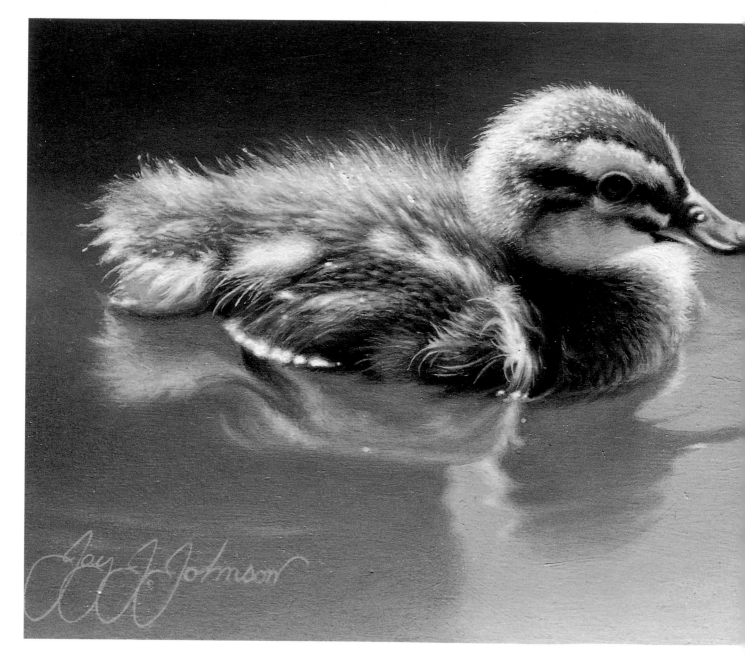

5 GLAZES OF COLOR

At this last stage, turn your attention to finishing the water. You want to exaggerate the transition from dark in the upper left to light at lower right. Again apply a thin paint layer and work wet-into-wet. This is when those stored 35mm film containers of paint come in handy, since wet paint looks slightly different from dry paint. Having premixed paint makes it much easier to match colors. Toward the lower right of the blue water area, add white. Toward the bottom of the brown reflection, add blue.

"The reflection of the head is substantially softened, more so than you would actually see in nature," says Johnson. He then harkened back to a childhood memory of an optical effect, saying that "as a youngster floating on an inner tube . . . I remember marveling at how sunlight penetrating the water beneath me turned the water translucent yellow." To achieve this effect, glaze over the water with pure yellow after the paint is dry.

As a final step for the duckling, selectively add warm glazes to some feather areas, including the colors Raw Sienna, Burnt Sienna and Cadmium Yellow Deep. Some darks (like just under the cheek) should receive darker glazes of color, which add more contrast.

JAY J. JOHNSON
"Duckling"
Oil, 4¼" × 7⅛" (11cm × 18cm)

More Books
for Creating Great Art!

Painting Watercolor Portraits that Glow—Jan Kunz's expert instruction, along with her own glowing portraiture examples, make this book an all-time favorite. Order yours and get Jan's secrets for painting accurate, lively, colorful portraits in 11 step-by-step demonstrations. You'll learn how to accurately draw the head and facial features, create the illusion of three-dimensional form; apply the laws of light to render brilliant darks, capture character and more. *#31336/$23.99/160 pages/200 color, 200 b&w illus./paperback*

Painting Nature in Pen & Ink with Watercolor—Claudia Nice is your guide on a treasure hunt through nature. Follow her clear, friendly instruction to paint birds, butterflies, fish, shells, flora and fauna . . . all the small, fantastic wonders of forests, tropical reefs, mountains, deserts, swamps and wildflower fields. This unique, light-hearted book is filled with sketches, notes, tips and step-by-step demonstrations—all leading to full-length projects alive with the joy of nature. *#31193/ $27.99/128 pages/100 color, 16 b&w illus.*

Splash 5: The Glory of Color—From the deep, moody blues of Bermuda to the simple poetry of a bright red watering pitcher, from delicate washes to thick, bold strokes, *Splash 5* celebrates masterful and inventive uses of color. You'll see 125 paintings from 109 of today's finest watercolor artists. Along with the beautiful reproductions, you'll find insights from the artists on the colors they use, and how you can use color to bring emotion, sensation and energy to your work. *#31184/$31.99/144 pages/130 color illus.*

How to Get Started Selling Your Art—In plain language, Carole Katchen tells you how to make a living—or just earn some spare cash—as an artist. You'll learn how to display your art attractively, establish prices, develop professional-looking business cards and stationery and assemble a portfolio. This book also describes the pros and cons of co-op, membership and juried shows, as well as galleries and art festivals. *#30814/$17.99/128 pages/paperback*

Watercolor: You Can Do It!—Besides being a fine artist, Tony Couch has a real knack for explaining complicated concepts in a simple, visual way. In this book, Couch teaches you what it took him years to learn, including how to compose a painting by thinking in terms of shapes and symbols; use just 10 basic hues to create all the colors you need; paint trees, skies, water, waves, rocks and grasses; and more! *#30763/$24.99/176 pages/160+ color, 150+ b&w illus./paperback*

The Art of Painting Animals on Rocks—Lin Wellford shows you how, with acrylic paint and imagination, you can turn ordinary rocks into incredible works of art! This book contains 11 step-by-step projects that are easy, creative and just plain fun. Each project includes patterns and photos of the finished piece. Follow along, changing colors and designs as you like. You'll find ideas and inspiration in the many color photos of Wellford's own rock creations. *#30606/$21.99/128 pages/250 color illus./paperback*

Perspective Without Pain—Designed to help you solve depth problems easily. You'll learn 6 techniques of perspective, how to portray rectangular objects in linear perspective, and how to develop your ability to handle the ellipse, the cylinder and the slant. *#30386/ $19.99/144 pages/185 color illus./paperback*

The Watercolorist's Complete Guide to Color—You'll learn how colors in paint behave; how to mix colors; wash and glazing techniques; how to "charge" one wet color into another; and how to choose a palette. Ten step-by-step demonstrations show color found in shadows, a white subject and a colorful subject, water, clouds and skies—plus how to paint nature's greens, intensify a color's brilliance, create distance with color and more. *#31106/$23.99/144 pages/200+ color illus./ paperback*

The Watercolor Painter's Solution Book—This visual solution book will help you recognize and identify problems in your work by showing you paintings with specific problems and how to solve each one. With this book, you'll soon be stepping back to take a look at your work and find yourself smiling at the results. *#30307/$21.99/144 pages/200+ color illus./paperback*

Exploring Color, Revised Edition—In this book, you'll learn the different characteristics of each pigment and when (and in what combinations) it's best to use them. Leland includes 83 clearly defined exercises that show you how to use color to plan stronger designs, create greater interest, develop better compositions, create striking harmonies, and convey powerful moods and emotions. Along with the examples, this book is richly illustrated with the works of many masters of color. *#31194/ $24.99/144 pages/244 color illus./paperback*

Painting Fresh Florals in Watercolor—Learn Arleta Peck's simple secrets for creating elegant, realistic watercolor florals. She'll show you how to layer colors to create a wealth of rich hues. (She's even included a handy color wheel of glazes for quick reference.) Next, step-by-step demonstrations will show you how to use glazes to paint magnolias, dogwood, daffodils, tulips, irises, roses, peonies, apple blossoms, leaves, lace and china. *#31182/$27.99/128 pages/220 color, 17 b&w illus.*

Zoltan Szabo's 70 Favorite Watercolor Techniques—Szabo has perfected 70 tried-and-true techniques over more than 60 years of painting. With this book, you can use the techniques in your work immediately for great effects. The techniques are presented in short, easy-to-follow lessons with step-by-step demonstrations showing many of the techniques applied. *#30727/$28.99/144 pages/230 color illus.*

Painting Beautiful Watercolors from Photographs—Jan Kunz shows how to create great watercolor paintings inspired by photos. Eight complete painting demonstrations illustrate specific techniques for working with photos of flowers, children, animals and other subjects. Nine before-and-after demos present problem photos that intrigued Jan and how she turned them into successful paintings. *#31100/ $27.99/128 pages/208 color, 58 b&w illus.*

The Artist's Photo Reference Guide to Flowers—You'll find gorgeous photos of 49 different types of flowers arranged alphabetically, from Amaryllis to Zinnia. Each flower is shown in a large primary photo, along with side views and close-ups of petals, leaves and other details. Many of the flowers are shown in an assortment of colors, too. Five step-by-step demonstrations in a variety of mediums show how you can use these reference photos to create beautiful floral paintings. With this unique book, you can use your precious time for painting, not research. *#31122/$28.99/144 pages/ 575 color photos*

Basic Techniques for Painting Textures in Watercolor—The seasoned advice in this book will help you "make your strokes strong, free and direct . . . and let texture happen." A compilation of some of the finest teaching on the subject ever published by North Light Books, this book contains art, advice and step-by-step instruction from 20 outstanding artists—including Carole Katchen, Claudia Nice, Zoltan Szabo and Frank Webb. In addition to exploring a range of texturing techniques, you'll learn to see runs, raindrops and other "accidents" as potential parts of your design. *#31104/$17.99/128 pages/ 320 color illus./paperback*

Painting Sunlit Still Lifes in Watercolor—Liz Donovan's watercolor still lifes are anything but still. They are infused with the sparkle, color and movement of sunlight. In this book, Donovan shows you how to capture the magic of sunlight in your watercolors. In 33 step-by-step demonstrations, you'll learn how to paint a variety of popular still-life elements, including lace, velvet, patterned fabric, glass, copper, silver, wood grains, marble textures, apples, peonies, irises and leaves. Includes great advice on choosing objects and arranging your still life, an easy preliminary drawing method, and four complete step-by-step painting projects. *#30900/$28.99/144 pages/235 color illus.*